BARRON'S
EZ-101
STUDY KEYS

D0289856

Robert Myron, Ph.D.,
Professor of Art History
Hofstra University

Art History

BARRON'S

New York • London • Toronto • Sydney

PLATTE COLLEGE
RESOURCE CENTER
COLUMBUS, NEBRASKA

© Copyright 1991 by Barron's Educational Series, Inc.

All rights reserved.
No part of this book may be reproduced in any form, by
photostat, microfilm, xerography, or any other means, or
incorporated into any information retrieval system, electronic
or mechanical, without the written permission of the
copyright owner.

All inquiries should be addressed to:
Barron's Educational Series, Inc.
250 Wireless Boulevard
Hauppauge, New York 11788

Library of Congress Catalog Card No.

International Standard Book No. 0-8120-4595-5

Library of Congress Cataloging-in-Publication Data
Myron. Robert.
 Study keys to art history / by Robert Myron.
 p. cm.—(Barron's study keys.)
 Includes index.
 ISBN 0-8120-4595-5
 1. Art—History—Study guides. I. Title. II. Series.
N5300.M96 1991
709—dc20 91-4630
 CIP

PRINTED IN THE UNITED STATES OF AMERICA

1234 5500 987654321

CONTENTS

N
5300
M 96
1991

31033

Theme 1 PREHISTORIC ART

*P*rehistoric art was produced before the knowledge of writing. The great achievement of the nomadic hunters from Spain to Siberia was the first representation of the animal world that was probably identified with magical and religious power. Images served to control or petition natural forces through rituals that ensured the survival of the bands and groups of people. Cave art prevailed for more than 20,000 years and the major art centers were in France, Spain and the Danube region. Despite the great antiquity of these first paintings and carvings, they are of a high aesthetic quality and captured the attention of modern artists. After the Ice Age, the Neolithic witnessed the discovery of agriculture, the establishment of communities, towns and the construction of monumental architecture, human images, pottery and painting.

INDIVIDUAL KEYS IN THIS THEME

1 Prehistoric art

Key 1 Prehistoric art

OVERVIEW *Upper Paleolithic nomadic hunters painted images in caves and carved animal and human figures. Mesolithic food gatherers painted human figures and animals on cliffs; Neolithic farmers built the first towns and monuments and modeled human and animal images.*

Paleolithic painting: Realistic images of bisons, horses, and cold-weather animals were painted on walls deep within the caves in the Pyrenees. Ranging in size from a few inches to 10 feet, they are often superimposed.
- The earlier **Aurignacian** style is distinguished by contours or deep-cut incisions filled in with red or black pigment.
- In the later **Magdalenian** age, animals were convincingly modeled in earth colors and portrayed in spirited, animated poses.
- Sympathetic magic to aid in hunting may have been the purpose of these paintings.

Paleolithic sculpture: Realistic small carvings of animals in bone, antler, and ivory probably served as hunting amulets. Sculptured abstract images of nude females **(Venuses)** with exaggerated emphasis on sexual characteristics—pendulous breasts, heavy hips and thighs—may have symbolized fertility.

Mesolithic painting: Painted outdoors on cliffs in Spain were the first scenes of warfare—stick-like male figures battling with bows and arrows and spears—and hunting scenes. Stylistically, animal images are rigid and angular.

Jericho: Permanent buildings and fortifications, constructed in the Near East at Jericho (Palestine) about 8000 BC, were oval brick houses protected by tall fortified walls with a tower and moat. Human skulls, covered with plaster and having inlaid eyes, probably represented ancestral spirits.

Catal Hūyūk (Turkey): A town here was built of mud brick supported by timbers about 6000 BC. Human images were modeled in clay, particularly fleshy nude females that probably represented an all-powerful earth mother derived from the Paleolithic age. The earliest known landscape painting, on a wall here, shows the city and volcano.

Megalithic monuments: Near the seacoasts of Europe are different alignments of megalithic monuments, of which **Stonehenge** is the most famous. These structures probably served as shrines, tombs, and astronomical sightings.

Theme 2 ANCIENT WORLD

*I*n Mesopotamia and Egypt writing was developed. Large cities, constructed of finely carved stone and brick, were ruled by imperialistic monarchs; powerful priests controlled the natural forces and gods and prepared rulers for life in the otherworld. Impressive discoveries were made and recorded in science, medicine, and mathematics. Artists were professionals who enjoyed high social status and designed tombs, temples, and palaces. Rulers, gods, family, courtiers, and scenes of everyday life and conflict were immortalized in stone carvings and paintings. Unfortunately, monuments built of impermanent materials like sun dried brick have not survived.

Key 2 Egypt: Old Kingdom

OVERVIEW *The agricultural society of Egypt grew up along the Nile. United around 3,000 BC and centered at Memphis in Lower Egypt, the Old Kingdom (dynasties II-VI) was highly stratified, with courtiers, officials, priests, soldiers, physicians, architects, sculptors, and painters all ruled by deified pharaohs.*

Religion: The polytheistic religion was characterized by anthropomorphic gods. The pharaoh, believed to be the son of the sun god Ra, was represented by a falcon. Because it is believed that he possessed a soul (*ka*) that had to be preserved for eternity and that death was simply an extension of life, art placed in his tomb reflected the pleasant aspects of the pharaoh's daily activities.

Architecture: The origin of the pyramid (Dynasty I) was the **mastaba**, built of mud-dried brick. Similar in shape but more monumental in scale was the step pyramid (Dynasty III), designed by Imhotep for King Zoser at Saqqara. The final form was the smooth-faced pyramids (Dynasty IV) built at Giza for Khufu, Khafre, and Menhaure, guarded by the Sphinx with the facial features of Khafre.
- Built on the west bank of the Nile, pyramids marked the pharaoh's entrance to the underworld. His absolute power is symbolized by the four sides of the pyramid oriented to the points of the compass.
- Each pyramid was surrounded by a walled community of loyal followers who maintained the burial grounds.

Sculpture: Sculpture was not simply decorative but had a real function. If the **mummy**, the preserved body, was destroyed, the *ka* could find refuge in the stone carvings of the pharaoh.
- The conservative society is reflected in the traditional seated and standing pose of the pharaoh, conforming to the rectangular block of stone from which the statue was carved.
- Stylistically, the pharaoh is defined with a powerful muscular body and an austere, commanding expression. More realistic are the full length portraits of his family, courtiers, and officials.
- In painted relief sculpture of groups, the pharaoh is identified by his greater size. Human figures are conventionalized, but animals are remarkably realistic.
- Accompanying these carvings are small wooden figures of workers and models of the many shops—bakery, butcher, brewery—that would provide for the pharaoh's needs in the otherworld.

Key 3 Egypt: Middle Kingdom

OVERVIEW *Egypt was reunited in the 11th dynasty by Mentuhotop I, only to be invaded again at the end of the 12th dynasty by the Hyksos who swept in from the east. This was an age of instability as the capital shifted from Lower to Upper Egypt.*

Society: The power of the deified pharoah declined and he assumed the responsibilities of an earthly ruler. The age was marked by a more pessimistic attitude toward life and death. Members of the increasingly important middle class believed that their afterlife depended upon their character and morality.

Architecture: Since pyramids had been plundered by robbers, tombs were now tunneled out of cliffs, like those at Beni Hasan, but these were also plundered.
- The forecourt at Beni Hasan was lined with fluted columns (proto-Doric style) with block capitals, and a curved ceiling was painted in a blue and white diamond pattern to symbolize the heavens.
- The mortuary temple of Mentuhotep at the base of the cliff at Deir el-Bahari was the most monumental structure of the period. It was destroyed in the New Kingdom, but remains reveal two superimposed terraces supported on square piers and probably surmounted by a small pyramid. A long processional path flanked by a series of recumbent sphinxes and enhanced with trees and vegetation led to the temple.

Sculpture: Royal carvings, like the brooding portrait of **Sesostris III**, are now more expressive. Many servant figures in tombs are more life-like, although those of priests and officials tend to have flattened bodies, tubular arms, and detached expressions.

Painting: Painted images in tombs, particularly those of animals, are increasingly realistic and the space more illusionistic.

Key 4 Egypt: New Kingdom

OVERVIEW *After the Hyksos were driven out, pharaohs (dynasties XVIII, XIX, XX) transformed Egypt into a vast empire with the capital at Thebes. The pharaoh, associated with the supreme sun god Amun-Ra, was supported by a powerful priestly class; the nobility and middle class enjoyed more privileges than ever before.*

Architecture: Enormous temples and rock-cut tombs were the major monuments. Within the hidden entrances of the tombs were huge statues of the pharaoh. Scenes of gods and the otherworld were painted on the walls and ceilings.
- Queen Hatshepsut's mortuary temple at **Deir el-Bahari** consists of three colonnaded terraces—covered with trees, vegetation, and royal reliefs and reached by ramps—leading to the holy of holies deep within the rock of the cliff.
- Temples at Karnak, Luxor, and other sites were enclosed by a high wall and constructed along a central axis divided into a succession of courts, pillared halls, and chapel.
- The **hypostyle** temples of Amun-Ra influenced Roman basilicas and medieval churches.

Sculpture: Tomb figures were slender and clothed in luxurious garments with accessories defined in complex linear patterns. Rameside pharaohs displayed in stone their imperial grandeur.
- Rameses II is represented in four huge statues that flank the entrance to his tomb at **Abu Simbel** (1290–1225 BC). Massive seated figures, they overwhelm the viewer in a bold, angular, block-like style.
- Pessimistic expressions on some royal figures reflect the complexities and conflicts of the age.
- Elegant female figures wear clinging diaphanous garments.

Painting: Tombs were lavishly decorated in a series of superimposed painted scenes.
- Sen-Nedjem, for example, is depicted in his tomb standing on a solar barque approaching the waiting gods. Below are bands filled with scenes of fruit trees, wheat fields, and workers in typical conventionalized style.
- Figures are more expressive and depicted with freedom of movement and a concern for space. Animals are more realistic, and the horse and chariot appear for the first time.

Key 5 Egypt: Akhenaten and Tutankhamen

OVERVIEW *Akhenaten's reign saw a break with tradition in both religion and artistic style, but after his death Egypt returned to the old ways.*

Akhenaten: In the XVIII dynasty Amenhotep IV changed his name to Akhenaten in honor of Aton—the new and only solar god—and made himself the earthly manifestation of this monotheistic cult. Severing all ties with the priesthood that had dominated Egyptian society, he moved his capital to Tell el-Amarna and dedicated the city to Aton. After his death his successors destroyed the buildings to erase his memory, but some sculpture and paintings survived.

Sculpture: Statues of Akhenaten and his family are referred to as the **Amarna style**. Over-life-size statues of Akhenaten show the distinctive anatomical traits: high cheekbones, thick fleshy lips, prominent jaw, pensive gaze, effeminate breasts, emaciated arms, and heavy hips. In another carving he stands holding a book in a *genre* pose typical of his reign. His legs are together (instead of in the characteristic stride), chest is sunken, and his head hangs forward on a narrow neck. His pot belly and heavy thighs are clothed in almost transparent drapery defined in a detailed linear pattern.
- In a stone bust Nofretete (Nefertiti), his wife, wears the crown of upper and lower Egypt and has the same prominent cheekbones and chin; full lips; long, slender, inclined neck; and elaborate facial make-up.
- In a stone relief, *Akhenaten and Family Sacrificing to Aton*, Aton is shown above a disk with a series of radiating lines ending in human hands that give life and offer protection to the royal family. Hieratic scale is evident in the large image of the king and smaller figures of the queen and their daughter.

Tutankhamen: Probably Akhenaten's half brother, he came to the throne as a young boy. His tomb, the only royal tomb ever discovered nearly intact, was found by Howard Carter in 1922. It took more than eight years to remove 2,000 magnificently carved and decorated objects from the tomb.
- Tutankhamen's coffins were superbly fashioned of gold and fitted one inside the other; the innermost coffin in solid gold weighed 243 pounds.

- A gold mask covered the face of the mummy and was inlaid with semiprecious stones and glass paste. The features convey a serene expression.
- A standing statue of Tutankhamen, life size with gilt decoration, retains Amarna traits, such as sunken chest, pot belly, thin limbs, narrow neck inclined forward, and the distinctive facial features.
- *Throne of Tutankhamen* is ornately decorated with an image of the seated king seated before Queen Ankhessenamen. Above is the disk of Aton with radiating lines extending downward towards the king.

Key 6 Mesopotamia: Sumeria and Akkadia

OVERVIEW *Mesopotamia, the land between the rivers (the Tigris and Euphrates), was the other great site of ancient art, but the exposed terrain was vulnerable to invasion.*

Sumerians: These people, who established the oldest civilization, probably came from Persia. Their theocratic-socialistic city-states were ruled by a local god through a human ruler, the steward of the deity.

Sumerian architecture: The multi-storied temple, or ziggurat, was about 40 feet high, and dominated such cities as Ur and Uruk, with houses, workshops, and storehouses clustered around it. Most famous was the biblical *Tower of Babel* (destroyed). Shaped like a mountain, where it was believed the gods dwelt, the sides were reinforced by masonry.
- The four sides were oriented to the points of the compass.
- Stairs and ramps led to an ornate shrine at the summit dedicated to the deity.
- The setbacks were probably planted with trees and vegetation to simulate a mountain.
- Worshippers started the ascent at the east and climbed in an angular spiral.

Sumerian sculpture: Stylistically, small figures were carved into a rigid cylindrical shape (unlike the cubistic Egyptian style) with tubular arms clasped on a long, skirted body, large inlaid eyebrows and eyes, and hair inlaid with gold or copper. Gods were larger in size with huge eyes and pupils fitted with colored inlays. Animals, sacred and important in mythology, were represented as inlaid decorative forms or free-standing like the rearing goat from Ur in wood, gold, and lapis lazuli.

Akkadians: The Sumerians fell to the Semitic Akkadians (2340–2180 BC), led by Sargon I, who extended his empire to the shores of the Mediterranean. After the empire collapsed, it was briefly united in 2125 BC by the kings of Ur; most important was Gudea, whose capital was at Lasgash. Because monuments were built of mud-dried brick and timber, few survive.

Akkadian sculpture: Royalty were realistically portrayed in bronze, bearded, with braided hair and large deep-cut eyes that convey a majestic and human expression.

- The benevolent king, Gudea, was carved with a round face and tense, cylindrical body.
- Naram-Sin, Sargon's grandson, was depicted on a stone stele defeating his enemies before a tall mountain with radiant stars overhead.

Key 7 Mesopotamia: Babylon and Assyria

OVERVIEW *After the fall of the Akkadians, Mesopotamia was briefly united by Semitic invaders led by Hammurabi and the kings of Ur, who established the capital at Babylon 1760–1600 BC. A strong and humane ruler, Hammurabi recorded the earliest law code and saw himself as the servant of the sun god Shamash.*

Babylonian sculpture: Figures are carved in stocky, cylindrical proportions typical of the region. The Law Code, inscribed in 3600 lines of cuneiform on a seven-foot-high diorite **stele**, was surmounted with the image of Hammurabi and the sun god Shamash. Stylistically, the figures are related to the Gudea statues.

Assyrians: The kingdom was conquered by the Assyrians, an aggressive nation of powerful military warriors who expanded their empire as far as Egypt and founded their capital at Assur 1000–612 BC. Assyrian rulers developed armaments and battlefield maneuvers that made them almost invincible. They were feared for the atrocities and tortures they inflicted on their enemies. For a brief period after the Assyrians fell to invaders from the east, Babylon was ruled by a series of kings; best known was Nebuchadnezzar who built the Tower of Babel, 612–539 BC (Key 6). Little remains of architecture from this period.

Assyrian architecture: With imported stone Assyrians built temples, ziggurats influenced by the Sumerians but on a more sumptuous scale. The reconstructed *Citadel of Sargon II* at Dur Sharrukin, the modern Khorsabad (end 8th century BC) covered 23 acres and was surrounded by turreted walls with two gateways. Within were 200 courtyards, rooms, and warehouses built of brick and reinforced with stone slabs. The walls were decorated with reliefs.

Assyrian sculpture: Massive, muscular humans and animals celebrating the military exploits of kings decorated walls at Khorsabad and elsewhere. These strong, aggressive images were defined in vivid detail.
- At the gateway in Khorsabad stand 14-foot-high statues of human-headed winged bulls with five legs, so they can be seen from the front and side.

- Reliefs on the stone walls of *Palace of Ashurnasirpal* at Nimrud depict royal lion hunts. The lions are convincingly shown attacking, wounded, and dying.
- Also shown is the brutal conquest of enemy cities.

Neo-Babylonian architecture: Few remains survive except for the majestic *Ishtar Gate* in Nebuchadnezzar's sacred precinct. A central arch marks the entrance and the sides are embellished with a multitude of baked and glazed brick images of bulls, dragons, and other creatures.

Key 8 Persia

OVERVIEW *Persia, inhabited since the prehistoric age, played host to a multitude of peoples, but took its name Iran from more recent arrivals who became empire-builders.*

History: From the prehistoric age Persia (Iran) was inhabited by migratory tribes who swept in from India and the Asian Steppes and settled in Luristan. It was absorbed into the empire of the Medes and Achaemenid dynasty ruled by Cyrus, only to fall to Alexander the Great in 331 BC. Cyrus' empire, the largest in the world, reached from the Indus River to the Danube and was divided into more than 20 provinces bound together by an extensive network of roads.

Luristan art: Small decorative bronze objects portray highly stylized animals that elude identification and are reminiscent of images painted on prehistoric pottery from Suza (5,000–4,000 BC). Surfaces were defined in complex interwoven linear patterns related to the so-called "animal style" seen from Siberia to Europe.

Achaemenid architecture: Huge impressive stone palaces exemplified the Achaemenid period.
- Persepolis, King Darius' imperial center, was begun in 518 BC. It stood on a vast terrace faced by a high retaining wall.
- Numerous main buildings were approached by a flight of steps wide enough for horsemen to ascend.
- Hypostyle construction is seen in the Audience Hall and Throne Room.
- Capitals were distinctively carved in "cradle" shape with confronting bulls and other creatures supporting ceiling beams. Other capitals were shaped in the palm and lotus designs of Egypt; fluted columns and scroll capitals came from the Ionian Greeks.

Achaemenid sculpture: Walls of Persepolis were covered with repetitious rows of painted figures in relief.
- Soldiers, courtiers, and tribute bearers move in a slow, solemn march, wearing the dress distinctive of different parts of the empire.
- Human-headed winged bulls derived from Assyria and the Royal Disc of Egypt are part of the decoration.

Sassanians: Art flourished again when, after falling to the Romans, Persia regained independence under the Sassanians and their great ruler Shapur I.

- The palace of Shapur I at Ctesiphon (near Babylon) has an enormous brick vaulted audience hall. Blind arcades decorate the facade.
- At Naksh-i-Rustam, the royal tomb of Shapur I is decorated in relief, portraying his conquest over the Romans in the 3rd century BC.
- Metalwork and textiles decorated in rich ornate designs and patterns flourished and influenced later Islamic art.

Key 9 Cycladic and Minoan art

OVERVIEW *Aegean civilization, roughly contemporary with Egypt and Mesopotamia, consisted of two centers—one on the Island of Crete (Minoan) and the other on the Greek mainland (Helladic). Few documents have survived; the script has not been adequately deciphered and knowledge of the civilization is vague.*

History: Cycladic seafarers buried their dead in stone tombs accompanied with sculpture. The Minoans on Crete, named after the legendary King Minos, came from the east and built several palaces; the best known is Knossos. They founded a theocratic government but left no images of kings or a priesthood. They practiced fertility rites and probably worshiped animals and trees.

Cycladic sculpture: Most of the figures found in tombs are female nudes carved in marble; these figures may have represented a cult goddess. Others are more secular such as seated musicians. They range in size from a few inches to almost life size.
- Stylistically, they are angular with a flat body, columnar neck, arms folded on the chest, tiny breasts, and an oval disc face devoid of features save for a long projecting nose. They were partly painted.

Minoan architecture: The Palace of Knossos was destroyed in 1700 BC and rebuilt, only to be devastated again in 1450 and 1400 BC.
- It contains hundreds of small rooms, connecting corridors and low staircases. Apartments have terraces, open galleries and low ceilings.
- The palace covered 3 to 4 acres and was several stories high with a central courtyard, air shafts, drainage system, latrines, and painted walls. It was airy, comfortable, and pleasant.
- Massive stone walls were supported on square piers; numerous short wooden columns were distinctively shaped with a cushion capital (prototype of Greek Doric) and a tapered base.
- Doorways were ornamented with colorful conventionalized floral designs.

Sculpture: Relief images were of stone or gold. Sculptured images in ivory and clay were small, such as the *Snake Goddess*, shown as a lavishly dressed woman holding snakes before her. The identity of the figure is controversial.

- Stylistically, Cretan figures have short torso, narrow constricted waist, long limbs, and sensitive facial features.

Painting: This was the great achievement of the Cretans. Walls were frescoed with scenes of young boys, girls, bulls, fish, luxuriant vegetation, and motifs such as rosettes, shields, and scroll patterns based on sea shells in lively, colorful patterns.

Key 10 Mycenae

OVERVIEW *Archaeological excavation revealed that the civilization celebrated by Homer had a basis in fact and was the forerunner of ancient Greek civilization.*

History: Mycenaeans built hilltop fortresses, spoke an Indo-European language, and were governed by powerful kings whom they buried in stone tombs. The Achaeans, who shared commercial and probably religious ties with Crete, were an aggressive militaristic society.

Architecture: The huge stone walls owe little to Minoan models.
- Citadel of *Tiryns* (13th century BC) consisted of a series of connected rooms and a palace with open courtyards built of mud-dried brick. The outer walls were constructed of huge uneven stone blocks in the style called **Cyclopean**.
- The **megaron**, or audience hall, was a distinctive structure marked by a columned gateway on the facade and with painted walls and floor. It contributed to the plan of Doric temples.
- The *Citadel of Mycenae* is entered through the megalithic-type *Lion Gate*, so-called because of the relief carving of two confronting lions facing a Minoan column, fitted into the triangular space above the lintel. The distinctive tapered column and cushion capital demonstrate the relationship between the two civilizations.
- The *Treasury of Atreus*, 1300 BC was a royal tomb with vaulted ceiling that had long since been plundered. Circular in plan, it was constructed in the **corbel technique**—superimposed courses of stone with smooth surfaces that terminate in a point resembling a beehive shape.

Decorative arts: Royal tombs excavated by Heinrich Schliemann (1876) contained many ceremonial and utilitarian objects of gold, silver, bronze, and other metals.
- A dagger, 1500 BC, inlaid with gold and silver, depicts a lively scene of men fighting lions.
- The *Vaphio Cups*, 1500 BC, a pair of exquisite gold cups in repoussé technique, portray men capturing bulls with ropes and nets. Figures conform to the Cretan style with broad shoulders, narrow constricted waist, long attenuated limbs, and sensitive facial features. The bull, massive and convincing, also reflects Cretan forms.
- An ivory group, 15th century BC, portrays fleshy buxom females, probably deities, with a small child imposed in an animated and intimate design.

Theme 3 GREEK ART

*G*reek art has influenced Western civilization down to the present. In city states, especially Athens, democracy first evolved, as did abstract reasoning, inquiry, philosophy, drama, poetry, and history. To survive in this rugged mountainous terrain, exposed to dramatic contrasts of climate and constant fear of invasion, demanded strength and intelligence. Man became "the measure of all things" and was portrayed with physical perfection and dignity. Greeks peopled their world with idealized immortal gods who functioned like themselves. Many works, particularly bronzes and panel paintings, are lost, and the colors have faded from temples and carved figures.

Key 11 Geometric and Orientalizing ages

OVERVIEW *Greek tribes swept into the peninsula from the north about 1100 BC, absorbed the Mycenaeans and expanded their power into Aegean Islands and Near East.*

History: The Dorians inhabited the mainland and the Ionians settled along the coasts of Asia Minor. The rugged mountainous terrain led to autonomous settlements that evolved into city-states ruled by militaristic monarchs. In the 7th century BC Greeks immigrated into southern Italy, Sicily, coasts of France, Spain, and other sites around the Mediterranean. Despite the dispersal, the Greeks, who called themselves Hellenes, shared a common language, beliefs, and customs. Beginning in 776 BC, they came together every four years to honor gods believed to dwell on Mount Olympus. Homer's Iliad and Odyssey illustrate this dynamic age.

Geometric pottery: The geometric style developed in the 8th century BC. Pottery was exported to the Near East and Italy.
- Tall funerary vessels decorated with a series of horizontal bands of geometric motifs were placed over graves of the dead.
- Burial scenes portrayed stylized human figures (triangular torso and rectangular head and limbs) in black against the reddish clay. Horses have tubular heads, bodies, and tails.
- Straight-line patterns of zigzags, triangles, frets, and swastikas and crosshatching fill surrounding spaces.

Geometric sculpture: Nude male figures and animals in bronze, not more than eight inches high, were cast solid in the geometric style of the painted pottery, with flattened torso, wiry limbs, and prominent facial features.

Orientalizing pottery: Corinth rivaled Athens as a pottery center. Vessels were now smaller and conform to seven basic types. Prominent, full-bodied painted figures and animals reveal influences from Near East and Egyptian trading centers, and designs illustrate myths and legends. Biting and fighting animals, composite strange creatures and curvilinear motifs exemplify the Eastern or Orientalizing style. Figures were painted in red and black and deeply incised.

Orientalizing sculpture: Small stylized bronze figures reveal eastern influences in distorted proportions and elaborate coiffure. Some rigid, frontal figures are prototypes of later Archaic carvings.

Key 12 Archaic period

OVERVIEW *In the 6th century conflicts erupted between the ruling aristocrats and the common people; stability was achieved by tyrants—some benevolent and others brutal. By the end of the century, revised constitutions paved the way for democratic government. Greeks felt themselves superior and called all other people "barbarians."*

Religion: Gods, led by Zeus, governed life and death. Given human attributes, the gods engaged in constant rivalry but were thought to possess great power, knowledge, and immortality. Sacrifices were made to the gods at outdoor altars.

Architecture: Temples, usually built on a hill, were the major public monuments. They did not serve for worship but housed in the **cella** the statue of the god they commemorated.
- Vertically, temples are divided into three main sections: a stepped platform, columns, and an entablature.
- Archaic temples were low and lacked a sense of proportion. Columns were short with flaring capitals in **Doric** order as at Paestum, Southern Italy. The *Treasury of the Siphnians* at Delphi was the earliest Doric temple.

Sculpture: The form and style of male nude (kouros) and clothed female (kore) figures were influenced by Egyptian pharaonic statues, evident in stride, block-like shape, frontality, broad shoulders, and arms along the side with fists clenched. Unlike Egyptian statues, they are fully free-standing.
- Early Archaic figures (600–525 BC) were conventionalized in style with anatomy defined by incised lines, bulging eyes, "archaic smile" and heavy plaited hair. Females wore thick under and outer garments. All figures were painted.
- Late Archaic figures (525–480 BC) were more realistically modeled; the smile was replaced by a calm, serene expression.

Painting: Paintings on walls and panels have vanished, but painted pottery rivaled architecture and sculpture and depicted mythological and everyday scenes. Drawings were filled in with flat, solid colors. Sometimes the names of the artist and potter were inscribed on the ware.

- Early Archaic (600–525 BC) figures and scenes were depicted in black against reddish clay **(black-figured technique)** and details were scratched in, as in the works of Exekias and Psiax. Sometimes the composition was accentuated with touches of white and purple.
- After 530 BC the **red-figured technique** prevailed and forms were portrayed in a freer, more realistic style as in works by Euphorons, and the Berlin and Brygos masters.

Key 13 Classical age

OVERVIEW *Classical canons of human beauty and proportion characterize the sculpture of this period. Figures are both naturalistic and idealized.*

History: After the Persian army was repulsed (480 BC), the Athenians established a democratic government headed by Pericles, who embarked on the construction of the temples and sculpture on the Acropolis to commemorate the gods who it was believed made the victory possible. During this Periclean Age, artists, historians, writers, dramatists and scientists flourished. From 431–404 BC Athens, Sparta, and other city states were engaged in the devastating Peloponnesian War. The 4th century was the age of Socrates, Plato, and Aristotle. In 338 BC Greece fell to the army of Philip of Macedon, who was assassinated two years later and succeeded by his son, Alexander the Great.

Early Classical or Severe Style Sculpture (480–450 BC): Kouros stand in *contrapposto* position with the weight on one leg, the other relaxed, giving the body a gentle curve while the face conveys dignity and a pensive expression.
* *The Charioteer of Delphi* (470 BC), a large bronze, wears a long garment of pliable and soft folds: mouth is short and eyes are inlaid with glass paste.
* *The Kritios Boy* (480 BC) is modeled with an undulating continuous surface that infuses the figure with a living spirit. Unlike Archaic statues, the figure is not symmetrical.
* Polyclitus was one of several acclaimed masters, most of whose works are known only from Roman replicas. *Spear Bearer* or *Doryphorus* (450–440 BC), stands in a relaxed S-shaped curve pose with flexed muscles and turned head that emphasizes his dynamic attitude. He conforms to a Canon of proportions, embodying the Classical ideal of beauty, comparable to the established proportions of architecture.

Golden Age sculpture (450–400 BC): This is best known by classical sculptures from the Parthenon. Figures are grouped in triangular compositions or in rhythmic sequences.
* *Three Goddesses* (438–432 BC) is conceived in depth with full, fleshy, animated figures clothed in thin clinging drapery that reveals the body beneath. The emphatically defined intricate folds became a common sculptural feature from now on.

- The powerful deity *Dionysus*, easily leaning on one elbow, is modeled with a smooth transition of muscles. The physical and emotional perfection exemplified the Greek ideal.
- The Parthenon frieze (Phidias and workshop) achieves an illusion of space as rounded forms of humans and horses display a rhythmic, spirited grace.
- *Stele of Hegeso*, one of many grave stele (often exported), portrays the seated deceased woman facing the undulating figure of a young girl. Their bowed heads convey a solemn pathos while the forms overlap the frame and emphasize the sense of space.

Painting: Pottery was decorated with three-dimensional, foreshortened figures in the same classical style, as on the white surface of *lekythoi* (oil jars) executed by the Achilles Painter. On a *krater* the Phiale Painter (440–35 BC) portrayed Hermes and Dionysus in brown, red, purple, and white as elegant, naturalistic figures.

Key 14 Greek architecture

OVERVIEW *Temples, usually built on a hill, were the major public monuments. They did not serve for worship but were designed to house the statue of the god that they commemorated.*

Construction: The earliest temples were apparently of wood; in time stone was substituted for the wood and conformed to the same shape. Temples were constructed of individual blocks of stone attached together with metal dowels—no mortar was used. Temples, like sculpture, evolved in style from the Archaic through the Hellenistic age.

Orders: Greeks built in three Classical orders—Doric and Ionic (named after their ethnic divisions) and the seldom used Corinthian. An order is a basic architectural system with its own vocabulary of elements.

Doric order: The oldest, it is distinguished by a column consisting of a fluted shaft with a swelling or entasis, square abacus and cushion-like echinus capital. The entablature is divided into an architrave, frieze or triglyphs and metopes, and a projecting cornice. Triangular pediments at the ends are often filled with sculpture; within the interior chamber (cella), the cult statue was housed. If the temple was surrounded by colonnade (peristyle) on all four sides, it was called peripteral. The Doric Order was influenced by Egyptian, Minoan and Mycenaean forms.

- Archaic Doric temple of *Paestum*, (550 BC) is low, heavy, and cumbersome with short columns, swelling entasis, and large flaring capitals.
- *Parthenon* marks culmination of the Doric Order. Designed by Callicrates and Ictinus 448–432 BC it had lighter proportions, slender columns, and aesthetic innovations or ''refinements'' that compensate for the optical illusion, reflect its elasticity and enhance its beauty. Pediments were filled with over-life-size sculpture; a continuous frieze, 550 feet long, encircling the temple was painted and embellished with metal ornaments.
- *Propylaea*, or Gateway Building (Mesicles and Ictinus), 448–432 BC, is also Doric Order but has a central passageway of Ionic columns and two wings—one housed first picture gallery in West.

Ionic order: Lighter and more graceful than Doric, the Ionic columns are extremely tall and slender with a slight entasis, round base, and a distinctive scroll-type capital.

- *Erechtheum* (421–405 BC) on the Acropolis in Athens is unusually assymetrical in form. Most famous of the three porches is *Porch of the Maidens*, supported by six caryatid figures in the manner of the two caryatids on Treasury of the Siphnians, Delphi, 530 BC.
- *Nike Temple* (427–424 BC), probably based on a design by Callicrates, has two porches, compact proportions, and a sculptured frieze.

Corinthian order: It differs from Ionic only in its distinctive acanthus leaf capital.

- *Monument of Lysicrates* (334 BC), Athens, marks the earliest exterior appearance of Corinthian order. Columns are engaged on a hollow miniature tholos that supports the tripod won by Lysicrates.

Theaters: At Epidaurus (350 BC), a vast open air theater built on a hillside contains concentric rows of seats separated by staircase aisles. The circular orchestra is in the center, and a hall-type structure (*skene*) behind the proscenium supports the scenery.

Key 15 Hellenistic age

OVERVIEW *Art from the beginning of the 4th century to the time of Alexander is called Pre-Hellenistic or late Classic; thereafter, Hellenistic.*

History: After the death of Alexander, his empire was divided into three territories ruled by his generals who became semi-divine, despotic monarchs. Cities burgeoned with a mixed population bound together by international trade based on coined money.

Society: Class distinctions were sharpened. The philosophies of Epicureanism and Stoicism and mystery religions appealed to many individuals. Remarkable achievements were made in astronomy, mathematics, geography, medicine, and physics. Art centers were outside the Greek mainland, though Athens was venerated for its learning. Art became a commercial product, bought by cities and owned by kings, generals, and rich merchants. Factories flourished to keep up with the demand.

Hellenistic architecture: Cities were designed on a gridiron plan such as Priene, Asia Minor, with libraries, parks, gardens, palaces and temples.
* *Altar of Zeus* (180 BC), Pergamum (reconstructed in Berlin) commemorated the victories of Attalus I on a grand scale with vast open space. Ionic columns surround the top, and a great frieze covering the base is filled with dramatic, over-life-size figures.

Hellenistic sculpture: There are three styles of sculpture in this period: realistic, Baroque, and Rococo.
* Realism is represented in portrait busts with mirror-image likeness and in statues like *Seated Boxer* (bronze, c. 50 BC), battered and muscular, and *Old Market Woman* (marble, 2nd century BC), aged and decrepit.
* Baroque is evident in the *Battle of Gods and Giants* on the Pergamum altar—twisted, distorted, and contorted figures almost detached from the background. The dramatic power is emphasized by the strong dark and light accents, sweeping garments, and dynamic rhythm of the figures. Similar is *Laokoön* (marble, 1st century BC), where father and two sons vainly struggle to escape from the coils of a giant serpent. *Nike of Samothrace* (marble, c. 190 BC) alights on the prow of a ship with outspread wings thrust into space and enveloped in sweeping garment.

- Rococo refers to nude and semi-nude Aphrodite figures standing in a graceful sensuous pose as well as charming, playful children and young boys.

Painting: *Battle of Darius and Alexander* (Roman copy of a Hellenistic painting, c. 300 BC) depicts a turbulent scene of animated soldiers, foreshortened horses and illusionistic space.

Theme 4 ROMAN ART

*B*efore the Republic, the Etruscans in northern Italy, contemporaries of the Greeks, buried their dead with a wealth of art forms. By the 1st century BC they were absorbed by the Romans into the greatest empire of the ancient world. Wherever they ruled, the Romans imposed their language, customs, religion, art, order, and sense of organization. Romans were influenced by the peoples they conquered, particularly the Greeks, from whom they borrowed gods, religion, mythologies, and art forms. The militaristic, legal, and administrative foundations of the The Empire produced not only efficient, well-planned cities, roads, bridges, and aqueducts but also remarkably realistic portrait and figural sculpture and painting.

Key 16 Etruscans

OVERVIEW *The Etruscan confederation of city states ruled Italy between the Tiber and Arno Rivers for about 400 years until conquered by the Romans in the 3rd century BC.*

Society: Etruscan city states were ruled by powerful kings supported by an aggressive military armed with chariots, horses, and iron weapons. They had a script but it has not been adequately deciphered. Etruscans adopted Greek gods, practiced divination, believed in an afterlife, and buried their dead in tombs. Impressed by the Greeks, they emulated Athenian temples and styles of sculpture.

Architecture: Little survives except for city walls and large tombs.
- Etruscans built protective city walls (Perugia) of massive masonry blocks and pierced with arched entryways.
- They buried their dead in rectangular stone tombs and large conical mounds of earth reinforced with a masonry base. Within, stone rooms recreated rooms in a ruler's palace.
- Etruscan temples (reconstruction) were similar to Greek but bulky and awkward in proportion. Placed on a podium with a flight of steps at one end, a columnar porch had a heavy overhanging roof decorated with terra cotta figures attached to a ridge pole.

Sculpture: Etruscans preferred to work in terra cotta and bronze and followed the Greek style, though a generation behind. There are also many stone sarcophogi.
- Incinerary urns were capped with statues of human heads; large sarcophagi were shaped like a couch surmounted with the reclining figures of the deceased man and his wife.
- Stylistically, figures are stocky, vigorous, animated, and arranged in a variety of positions.
- Images were incised in same lively style on bronze objects such as mirrors.

Painting: Etruscans frescoed the walls of their tombs with scenes that portrayed daily life, funeral feasts, religious rituals, and mythology, though the meaning is unclear.
- Stylistically, figures and scenes were based on Greek painted vases that the Etruscans collected and buried in their tombs. Forms are stocky, muscular, and richly colored. Some of the finest paintings were made in the 6th century BC.

Jewelry: Etruscans excelled in jewelry—exquisite gold ornaments, delicate plaques, tiaras, and pins.

Key 17 The Republic

OVERVIEW *Originally a small city state, Rome evolved into the greatest empire the world had ever seen. By 510 BC the Romans broke away from Etruscan domination; in the 3rd century BC they conquered Carthage and soon embarked upon world conquest.*

History: The Republic was ruled by two consuls, public officials, and the senate. Trade and commerce flourished, and a burgeoning population demanded new lands for settlement. Romans granted citizenship to conquered peoples who then enjoyed the privileges of a law code and military protection. Before the birth of Christ, the Republic was shaken by civil conflicts and military leaders strove for power. The Republic ended when Octavius became emperor in 27 BC.

Architecture: Roman construction was monumental, functional, and demonstrated remarkable engineering skills. Use of the arch, vault, dome, and concrete permitted grand scale, variety of shapes, and rapidity of building.
- *Temple Fortuna Virilis* (probably dedicated to Fortunus), set on a podium with a flight of steps and a deep porch, was derived from the Etruscans, while the Ionic order and refined proportions were influenced by the Greeks. The circular *Temple of the Sibyl* uses monolithic Corinthian columns.
- Private houses at Pompeii and Herculaneum are as long and low as a modern ranch house, with an atrium, columnar court, roof opening directly above a basin or pool, mosaic floors, and richly painted walls.
- Apartment houses were block-like and about three stories high.

Sculpture: Naturalistic sculpture in stone and bronze reflected the power and vanity of aristocratic patrons. The majority of sculptors were of Greek ancestry.
- Portrait busts and standing figures were influenced by Hellenistic and Etruscan expressionistic realism.
- Working from wax death masks, the Romans achieved great fidelity to nature in modeled and defined facial details. Complex linear patterns defined the folds and textures of long togas.

Painting: Homes (Pompeii) were decorated in four styles:
- The first (Incrustation, 220–60 BC) consists of white-framed red, green, and tan painted panels.

- The second (Architectural, 60–20 BC) is distinguished by illusionistic architectural structures, stage-like scenes, and mythological landscapes.
- The third (Ornate, 20 BC–60 AD) depicts fanciful architectural elements with small elegant scenes.
- The fourth (Intricate, 60–79) reveals the most illusionistic and imaginative architectural and landscape vistas.

Key 18 The Empire

OVERVIEW *The Empire was founded in 37 BC by Octavius (Augustus), who transformed Rome from a city of brick to one of marble.*

History: The Augustan peace and prosperity (Pax Augusta) was shattered by ambitious generals who competed for control of the empire. By the 3rd century, law, order, and administration began to collapse, with political problems compounded by foreign invasions, debased coinage, rampant inflation, and stagnant agriculture and trade.

Religion: Neoplatonism was the prevailing philosophy. Mystery religions, with deities like Isis, Cybele, and Mithras, offered salvation of life after death. Emperors were deified and small temples were built in their honor.

Architecture: Monumental buildings represented the grandeur and strength of the empire and reflected its organization, planning, and systematized construction methods.
- The **forum**, the heart of all cities, was laid out on an axial plan and flanked by a colonnaded plaza containing basilicas, temples, and administrative buildings.
- **Aqueducts**, constructed on a series of superimposed arches and carrying water to the cities (300 million gallons a day into Rome), exemplified the engineering skill of the Romans.
- The *Colosseum*, a masterpiece of Roman engineering and architecture, could seat more than 50,000 spectators on marble benches. The exterior three stories show Roman **arch and vault** construction framed by decorative Greek columns bearing a lintel (Roman arch order). Invented by the Romans, colosseums were built throughout much of the Empire.
- The *Pantheon*, built by Hadrian, influenced architecture from the middle ages and Renaissance through the 19th century. The concrete **dome**, 143 feet in diameter, was supported on cylindrical walls derived from the **tholos** tradition. The interior, illuminated by a single opening or **oculus** in the dome, is an overwhelming spatial experience.
- **Triumphal arches**, a Roman invention, commemorated the victories of generals and were built throughout the Empire (64 stood in Rome alone).

- Of the more than 952 baths, most spectacular was *Baths of Caracalla*, 700 feet long, illuminated by **clerestory** windows, roofed with ornate **groined vaults**, and lavishly decorated on the floor and walls.
- Apartment houses, like those at Ostia, reached up to five stories in height.
- **Basilicas**, which served as administrative and judicial buildings, were derived from the Egyptian hypostyle hall. They had a nave, side aisles, clerestory, groin vault, and ornate interiors.

Painting and mosaics: Mosaic scenes decorated the floors and walls of buildings and emulated the style of painting.
- Representative is the mosaic *Exploits of Hercules* (early 4th century) from Imperial Villa, Sicily. Against a light background, a powerful muscular warrior, horse, and bull are convincingly rendered in light and shadow conveying the excitement of battle. In mosaics after 50 AD, human figures and animal forms were rendered in black silhouette on a white ground.
- In Egypt (Fayum region) naturalistic portraits were painted in **encaustic** and **tempera** on wood panels fitted into the top of mummy cases containing the body of deceased Romans. Large dark eyes express a haunting, otherworldly quality.

Key 19 Roman Empire sculpture

OVERVIEW *Portrait busts were the major Roman contribution to sculpture. Imperial busts were produced and displayed in public places throughout the Empire. The sculptural style became increasingly abstract in the third and fourth centuries with an emphasis on inner feelings and emotions.*

Vespasian (75 AD): This realistic likeness of the bald, aged emperor shows him with a calm, self-assured expression and open, sightless eyes. Sculpture of this Flavian period is marked by warm tonal values.

Portrait of a Lady (90 AD): Her towering coiffure of tight curls, undercut with the extensive use of a drill, contrasts with her beautiful, sensitive features.

Marcus Aurelius (180 AD, bronze): This equestrian statue shows the emperor with arm extended in oratorical gesture, curly hair and beard, astride a remarkably realistic horse; it exerted great influence on Renaissance sculptors.

Triumph of Titus (81 AD): This typical example of historical relief sculpture is across the archway of the Arch of Titus. Within the deep space, figures carrying the spoils from the Temple of Jerusalem move with ease. Those carved in high relief are almost free-standing, and the resultant dark and light patterns enhance the drama of the event.

Caracalla (211–217 AD): A brutal man, the emperor is shown in the 3rd century style with contorted eyebrows, deep-set eyes cast in shadow with eyelids and pupils defined, wrinkled forehead, and intense expression of anger.

Philip the Arab (244–49 AD): The portrait of this emperor shows furtive undercut eyes, furrowed brow, a worried expression, and summarily modeled face.

Battle between Romans and Barbarians (250 AD): This emotionally charged relief is the front panel of a sarcophagus. The figures are contorted and disproportionate in an all-over design dramatized by dark and light patterns.

Constantine (310 AD): In the distorted 4th century style, the head has huge enlarged eyes with undercut iris and deep punctates for pupils; compressed forehead; thick rope-like eyebrows; and boldly cut features. It was originally part of a colossal statue.

The Tetrarchs (305 AD): This 4th century relief has embracing paired figures, each clutching a sword in one hand. The short, compact group has overly large heads, contorted brows, wide eyes, schematic drapery, and stiff, cylindrical bodies distinctive of the late Roman style.

Theme 5 EARLY MIDDLE AGES

After the fall of the Roman Empire, Christianity, centered in Rome and Constantinople, became the unifying force in Europe. Churches were built and enhanced with sculpture and mosaics that avoided the depiction of the nude body and realistic proportions. While Rome was at the mercy of the Barbarian tribes, the Eastern Church in Constantinople, capital of the Byzantine Empire, became powerful and wealthy, built the awesome church of Hagia Sophia, and produced a multitude of ornate icons. Monasteries became the centers of learning and art. Emphasis on the mysticism of the otherworld was exemplified by formalized and abstract shapes, patterns, and colors. After the 6th century, Islam came in conflict with Christianity and Muslims swept across North Africa into Spain, where they introduced a complex, decorative linear style.

INDIVIDUAL KEYS TO THIS THEME	
20	Early Christian art
21	Byzantine art
22	Islamic art
23	Celtic-Germanic art
24	Carolingian-Ottonian art

Key 20 Early Christian art

OVERVIEW *The Early Christian period dates from the time of Christ to the 6th century. In Rome, painting, architecture, and sculpture were influenced by pagan Roman styles but expressed the Christian hope of eternal life.*

History: Despite earlier persecutions, Christianity became the official religion of the Roman Empire in 389. Differences of doctrine split Christianity into the Western Church, where the Bishop of Rome was the supreme head, and the Eastern Orthodox, where the Church was subordinated to the secular authority of the Emperor. By the 6th century Constantinople had grown into a powerful and prosperous empire, while Rome was shattered by Germanic invasions.

Catacombs (2nd and 3rd centuries): In an underground network of over 500 miles of tunnels, chambers, and galleries beneath the city of Rome, Christians and other peoples were interred and the earliest Christian art appeared.
- Frescoes painted on the walls in the Roman style portrayed praying figures (*orans*), the Good Shepherd who came to represent Christ, and scenes from the Old and New Testament—Jonah and the Whale, Daniel in Lions' Den—that symbolized the rescue of the faithful from imminent death.
- Also in the Catacombs were stone images of the Good Shepherd and stone sarcophagi decorated with Biblical scenes in the Roman style.

Architecture: Old St. Peter's (333) was the first Christian church and the model for all others in the West. Among the Roman characteristics are the basilica plan, nave, side aisles, clerestory rows or arches and columns, and mosaic floor. Christian innovations include placement of the entrance at the short side of the plan, usually the west, so all lines converge towards altar, flat timber roof, modest proportions, and walls covered with mosaic scenes.
- Churches, domed, round, or polygonal, also served as mausoleums, baptistries, or chapels. The round, domed *Santa Costanza* (mid-4th century), originally a mausoleum, later became a church.

Mosaic: Didactic images in glass **tesserae** covered the walls of churches and, when struck by light, conveyed a spiritual mysticism.

Manuscripts: Christians were "People of the Book," and manuscripts were essential in their religion. They painted on parchment and vellum. The first illustrated Codex was the pagan *Vatican Vergil* (4th or early 5th century). Illustrators worked in the late Roman style, evident in overly large heads, large dark eyes, and descriptive costumes in dark and light contrasts.

Sculpture: Relief scenes from the Old and New Testament in the Roman style decorated stone sarcophagi of wealthy Roman Christians. Ivory plaques, whether commemorating the marriage of two Romans or depicting saints and apostles, reveal the persistence of the idealized Classical tradition.

Key 21 Byzantine art

OVERVIEW *Founded on the site of the old Greek city of Byzantium, Constantinople was to be the "New Rome." Byzantine art is a mixture of Classical and Eastern styles.*

Architecture: Byzantine architecture is distinguished by a domed central plan in contrast with basilica churches of the West. The earliest examples are found in Ravenna, Italy, center of Byzantine rule.

- *Tomb of Empress Galla Placidia* (425) is built in the form of an equal-arm cross.
- *San Vitale* (526–547) has a two-story octagonal plan influenced by Santa Costanza. The bare brick exteriors give little hint of the lavishly decorated interior. Within, eight piers support eight great arches; the lantern above is rounded off by tiny arches (squinches) between the windows. Capitals are basket-like with a square at the top, circle at the bottom, and covered with a welter of vine scrolls. The interior is decorated with polychrome marble walls, veined marble columns, marble screens, and colorful mosaics.
- *Hagia Sophia* (532–537), designed by Anthemius of Tralles and Isidorus of Miletus, is the culmination of the Byzantine style. A longitudinal axis leads to a vast square crowned by a dome resting on four spherical triangles or pendentives that rise from the piers (origin may by Armenia or Iran). Pendentives were the greatest Byzantine contribution to architecture. The dome is reinforced by half domes covered with gold mosaic; a row of windows at the base conveys the illusion that the dome is suspended from heaven.
- Byzantine architecture influenced *St. Mark's*, Venice, and provided the model for Russian churches as well as Islamic mosques.

Mosaics: Stylistically, Byzantine figures are two dimensional and attenuated with tiny feet, small heads, large dark eyes, and luxurious garments set against gold backgrounds. *Example*: Justinian and Queen Theodora with their entourage on walls of San Vitale.

- A common image is Christ Pantocrator (all-ruler), who fills the dome of Byzantine churches. Long-haired and bearded, he holds the Gospel in his left hand and raises his other hand in blessing. The depth and power of his eyes and ornate halo and cross behind his head convey the intense spirituality of Byzantine art.

Icons: Images of Christ, the Virgin, and saints were painted on wood panels with gold backgrounds in the Byzantine style. Most precious are mosaic icons on wood panels. Similar figures were carved in relief on small ivory and metal plaques.

Key 22 Islamic art

OVERVIEW *Islamic art combines elements from the Early Christian-Byzantine style with the Persian artistic tradition. Under the Ottoman Dynasty (Constantinople, 15th century), Turks inspired by Hagia Sophia produced many variations of the mosque that blend into the city's skyline.*

Background: Mohammed's *Hegira* from Mecca to Medina in 622 marks the beginning of the Islamic calendar. Islam is a mix of Judaic-Christian traditions plus the revelations of Allah to Mohammed recorded in the Koran. Armed with the Koran and sword, Moslems set out to conquer the world for Allah; by the 8th century they governed lands reaching from Spain to India. All believers were equal and could reach God without complex rituals, saints or a priesthood—the word of God was the only reality. Caliphs who followed Mohammed united the religious and political leadership of Islam, centered in Baghdad and Damascus; Arabic became the legal and religious language of Islam.

Architecture: Mosques, palaces, and mausoleums were the major types of architecture. Forms borrowed from other civilizations were disguised behind rich, exuberant surface decoration on walls and ceilings complemented by colorful mosaic floors.

Mosques: These were simple structures with open space for the faithful who faced an ornate *qibla* wall marked with niche or *mihrab* that pointed in the direction of Mecca; to the right was the *minbar*, a lofty pulpit where the imam directed the prayers. Outside was a *minaret*, a tower where the muezzin called faithful to prayer five times a day, and in the open courtyard was a *sahn* or pool for ritual absolutions.

- These elements are found in the *Great Mosque of Damascus*, (705–711).
- *The Great Mosque of Samarra*, Iraq (848–852), was marked by a stupendous spiral minaret, 171 feet high, based on the principle of the ziggurat.
- Typical sharp-pointed minarets became popular in the 11th century. *Mosque of Cordoba*, Spain (786), contains a forest of columns supporting ornate superimposed tiers of scalloped arches in the distinctive horseshoe shape derived from the Near East or Spain.

Palaces: The few extant are designed as a block-like mass with towered fortifications as *Ukhaydir*, Iraq (8th century).

- The remains of *Mshatta*, Jordan (743), show lavish decorations with rosettes and a floral interlace containing mythological creatures in "arabesque" design.
- *Alhambra Palace*, Granada (14th century), boasts an exquisite *Court of Lions*, jewel-like refinement of porticoes, gardens, pools, chambers, courts, fountains, and delicate double and triple columns. The limitless variety of designs and stalactites in stucco denies the solidity of the stone and brick structure.

Decorative arts: Instead of holy images, Moslems produced a multitude of small objects typical of nomadic peoples—ivory, enamelled glass, metal, ceramics—all richly embellished in linear designs, Kufic ceremonial script, and color. Tin glaze ceramics, invented in Baghdad (influenced by China), led to lustrous wall tiles first found in Great Mosque, Kaironan (862).

- Textiles, highly valued and made in the imperial factories of Iran, were influenced by Sassanian and Coptic traditions.
- Calligraphy was superior to painting and distinguished by bold yet graceful style.
- Manuscript painting (Iran and Iraq), influenced by China in the13th century, illustrated hunts, ballets, feasts, music, and romantic stories. Figures were flattened and wore delicate flowing robes, all precisely defined in line and arranged within compressed non-perspective space. Vivid colors and intricate patterns were set off by broad margins, as Junard's *Bihzed In The Garden* (1396).

Key 23 Celtic-Germanic art

OVERVIEW *As the Roman Empire disintegrated, Germanic tribes swept over Western Europe bringing with them a metalwork art unlike that of Mediterranean cultures. In monasteries, particularly on the islands of Iona and Lindisfarne off the coasts of Britain, Celts embellished manuscripts in an extraordinarily intricate style.*

Sculpture: Superb metal workers, these peoples fashioned buckles, amulets, and decorative forms in a distinctive "animal style," with imaginative creatures that reflected both life in the forests and on the steppes and the legends and superstitions that were part of their culture.
 • Small decorative forms representing highly fanciful and stylized animals and birds were made of bronze and gold, sometimes studded with precious and semi-previous stones (Merovingians and Celts).
 • Composite and contorted creatures were combined with sweeping whirls, tendrils, scrolls, and interlaced ribbons. From the *Sutton Hoo* ship, buried on the English coast as a memorial to an Anglian king, have come decorative objects as a *Gold and Enamel Purse* (c.650), bearing the motif of a man confronting creatures, eagles fighting ducks, and biting and fighting animals that form an interlaced pattern.
 • Vikings enhanced weapons, jewelry, grave stones, and prows of ships with welter of complex linear designs. The *Animal Head* from the Oseberg ship burial (825) displays bared fangs, bulging eyes, and rich interlaced patterns.

Painting: The rich complex style of painting of illuminated manuscripts of Gospel texts represented an act of service to God.
 • On the east coast of Scotland, Bishop Eadfirth created the *Lindisfarne Gospels* (698–721) with interlaced patterns combined with strange creatures and elements related to the contemporary style of jewelry and possibly to Egyptian Coptic art. With intense concentration, patience, and discipline, the artist defined single strands in a labyrinthine pattern that can be followed as seamless fabric.
 • The binding of the *Book of Durrow* (680) was embellished with precious materials that gave both beauty and significance to the text.

- *Book of Kells* from the island of Iona (Ireland) was completed about 800, before the island was plundered by the Vikings (807). Distinctive are the more than 2,000 capital letters that mark passages of the four Gospels, defined in a labyrinthine complexity comparable to fine goldsmith work. The Chi-Rho monogram for example, consists of tight scrolls, intricate knots, and whirling circles out of which emerge tiny heads of angels, men, and animals.

Key 24 Carolingian-Ottonian art

OVERVIEW *Concerned with the classical past, the court of Charlemagne collected Roman literature and encouraged a classical revival in the visual arts (Carolingian Renaissance).*

Architecture: Few buildings survive. Best preserved is the *Palatine Chapel* of Charlemagne's palace at Aachen, designed by Otto of Metz. The octagonal plan was based on San Vitale but the space has a strong vertical axis. Sturdy piers, polished granite, and marble columns with finely carved Corinthian capitals mark the interior. Charlemagne's throne was placed in the first gallery above the door and facing the main altar. **Westwork**, monumental entrance structure, is a major innovation of Carolingian architecture.

Painting: In the scriptorium of the monastery, monks not only illuminated manuscripts but also copied works of pagan authors.
- Saints, often shown writing, reveal classical influences but are rendered in frenzied, linear, ecstatic style, as in the *Coronation Gospels* and *Ebbo Gospels*.
- Manuscripts from the Reims School, France, show looser, more freely defined figures.

Ottonian art: Germany became the leading nation in Europe during the rule of five Ottonian kings, and Cologne became the major art center.

Architecture: Monastic buildings set the stage for the later Romanesque.
- St. Pantaleon, Cologne (980), one of few surviving monuments, has such Roman traits as massive stone walls, splayed windows, bell towers, and decorative blind arches. Impressive are the two arms of the westwork and western porch, almost equal in length, that extends from the square crossing tower.
- St. Michael's, Hildesheim was designed by the Bishop of Hildesheim, St. Bernward (d.1022). The interior space is divided into clearly articulated units: two chancels, two transepts, two apses all mathematically based on equal squares. On the exterior, the westwork is at right angles to the choir and an apse is covered by square towers over the crossings.

Sculpture: The bronze doors of St. Michael's (Hildesheim, 1015) are the major sculptural monument. Fifteen feet high, they illustrate 16 scenes from the Gospels in the Byzantine style. (Otto had married a Byzantine princess). Figures are imbued with the intense emotion and expressive power that characterizes German art.

Painting: The *Hitda and Uta codices* (c.1000) were produced in the spirited and colorful classical-Byzantine style.

Theme 6 LATER MIDDLE AGES

*D*uring the feudal age of the 11th century, the Roman Catholic Church consolidated its power in Europe, manifested in the Crusades, pilgrimages, monumental churches, and sculpture. After 1100, cities emerged, dominated by burghers who were involved in manufacturing and international banking. Paris, capital of a powerful king and court, became the mercantile center of Gothic Europe. Universities replaced monasteries as centers of learning and the predominant philosophy of Scholasticism was exemplified in the structure and spirit of Gothic Cathedrals. Gothic art became elegant, sumptuous, and colorful, as seen in manuscript illumination, stained glass, decorative arts, and panel painting.

Key 25 Romanesque in France

OVERVIEW *After a multitude of conflicts and move-ments of peoples, Europe as we know it emerged in the 11th century. Monasticism and feudalism were the major institu-tions of the age, 1000–1150.*

Society: In the absence of any strong governments, the Church was the unifying force and it marshalled the lords to embark on the Crusades, the first in1096. Society was theoretically divided into three classes: those who fought (lords), those who prayed (monks), and those who worked (serfs). Pilgrimages diffused what culture existed from one region to another.

Architecture: Romanesque churches are distinguished by a central nave, side aisles, Roman masonry, barrel vaults, arches, tall bell towers, and few small, arched windows that allowed little light into interiors. Exteriors are decorated with sculpture and architectural ornament. France was the great center of stone churches and sculp-ture.

St. Sernin, Toulouse (1080–1120): Typical of the Romanesque style, it was built on a grand scale. The plan conforms to the Latin cross. A tall octagonal bell tower crowns the crossing and is decorated with Roman round arches.
- The interior consists of a series of barrel vaults supported on mas-sive piers that create identical vertical volumes of space from nave to altar.
- Above the side aisles are upper galleries to handle crowds of peo-ple.
- An ambulatory (chevet) runs behind altar with radial apses for chapels where relics were housed.
- The exterior of the heavy, fortress-like structure is enlivened by round arches, colonettes, and other Roman motifs. The formidable facade, severity, and lack of decoration exemplify monasticism.

Sculpture: Romanesque marks the revival of monumental sculpture. Figures are disproportionate in size and attenuated, with the physical structure hidden beneath long enveloping drapery defined in a con-ventionalized style.
- Church exteriors in Burgundy were embellished with relief carv-ings on tympanum and jambs; in the interior, capitals were carved with biblical scenes.

- Monumental tympanums above the entrance exemplify the three basic styles of the Romanesque. The concept of illustrating a story on stone is Roman; the tall, flattened figures with small heads and complex linear drapery are Byzantine. The strange monstrous creatures and ornate interlaced motifs reflect the "animal style."

Painting: Illuminated manuscripts on vellum show elongated Romanesque figures. Those who painted small scenes were known as miniators; initial letters were done by rebicators. Pictures were enhanced with gold leaf.

Textiles: The *Bayeux Tapestry* (12th century), embroidered on linen 230 feet long and 20 inches wide, tells the story of William the Conqueror's invasion of England using typical Romanesque figures and forms.

Key 26 Romanesque in England and Germany

OVERVIEW *Conquests brought Norman influence to England; German kings extended their power as far as southern Italy.*

History: After the Norman conquest, Henry II brought stability to England, reduced the power of the nobles, and introduced a law code that led to Common Law and the grand jury system. Later, conflict erupted with nobility and clergy, resulting in both the murder of Thomas Beckett and signing of the Magna Carta (1215). In Germany, Frederick II headed the Holy Roman Empire, ruled Sicily and southern Italy, and established himself as divine-right despot. After his death the popes annihilated the family line.

English architecture: Norman style influenced English churches.
- *St. Etienne*, Caen, shows the basic Norman style. Two towers on facade, four broad buttresses, alternating compound piers in the nave soaring to new heights, sexpartite vaults, and complex piers contributed to the Gothic style.
- *Durham* has the long slender proportions and strongly projecting transept of English Romanesque churches. It measures 400 feet long. The pillars are ornamented with abstract patterns derived from metalwork. Pointed arches in western part nave are a pre-Gothic trait.

German architecture: The cathedral of *Speyer*, Rhineland, remodeled 1082–1106, boasts the highest vault, 107 feet. To support the weight, it has an alternating system of piers and columns characteristic of 12th century vaulted churches. The cathedral was designed with two series of clerestory windows, stepped arcade gallery above the nave, west-work, a nave almost four times the size of the crossing, and soaring towers that create a silhouette against the sky.

Painting: Manuscripts are particularly striking, such as *Bible of Bury St. Edmunds* (early 12th century) from England. Against a blue background, figures of Moses and Aaron, in graceful refined poses, speak to an intent receptive group of Hebrews. Form, defined in fluid linear pattern and rendered in bright colors, dominates the two-dimensional space in a superb surface design. The scenes are set off with an ornate, colorful, floral border.

Key 27 Romanesque in Italy

OVERVIEW *Wealth and prosperity in northern and central Italy and Naples led to impressive church architecture. Italian churches adhered to the basilican plan, classical forms, and horizontal orientation in contrast to the more vertical churches north of the Alps. Many churches were enhanced with white and green marble patterns.*

Baptistry (Florence, 11th century): This octagonal, block-like structure has a Roman foundation and interior pointed dome. The exterior is marked with blind arcades, pilasters with Corinthian capitals, and green-and-white-striped columns and arches.

San Miniato al Monte (Florence, 1018–1062): Built on a high hill overlooking the city, it is a commanding presence. It has the basilica plan with a refined Corinthian columnar arcade and a green and white marble pattern facade, surmounted with a well-proportioned pediment over the nave.

Cathedral complex (Pisa, 11th–12th centuries): The church conforms to the Latin cross basilica plan and has a pointed dome over the crossing. Most Romanesque churches were built by anonymous architects; this one was designed by Bushetus and based on the plan of Hagios Demedtrios in Salonika. The facade is covered by superimposed classical blind arcades that encircle the church. Each end of the transept is marked by an apse while the interior has a flat timber roof (decorated with a coffered ceiling during the Renaissance).

- Baptistry (begun 1153) is a round structure embellished with blind arcades (the upper stories were added in the Gothic period).
- Leaning Tower (Campanille, begun 1174) is cylindrical in shape, decorated with a series of superimposed arcades. It began to lean during construction, and efforts to reinforce the structure created the curve shape.

Sculpture: Antelanini's relief *Descent From the Cross* (Cathedral of Parma, 1178), although influenced by Roman reliefs, conveys a charming, naive, spiritual quality distinctive of the Romanesque age. The stiff vertical figures have large heads and complex linear network of drapery that conveys an emotional feeling. The background is enhanced with a delicate floral pattern and sharp-cut inscription.

Painting: Many remains of Romanesque frescoes survive in Italy, France, and Spain. Best preserved are those at Tahull (northeast Spain, early 12th century). Christ is shown in majesty, frontal, with a tall, elongated body, broad folds of drapery, delicate hands and feet, and an intense, commanding facial expression. Saints, placed within arches, are separated by columns and richly painted to make a strong, bold impact on the faithful.

Key 28 Gothic in France

OVERVIEW *Gothic was born in the region of Paris (Ile de France). Cathedrals built in the center of the city were a summation in stone and glass of the knowledge of the time.*

Society: This was a secular age of towns, cities, universities, traders, merchants, bankers, guilds, powerful kings, and luxurious courts. Scholasticism, the dominant philosophy and theology, exerted an impact on the arts. Women were given a new importance inspired by the Virgin Mary, and many cathedrals were dedicated to her (Notre Dame).

Architecture: French Gothic Cathedrals are designed with pointed arches, groined vaults, and flying buttresses. The plan is compact and unified; the nave, divided into oblong bays, is supported on clustered ribs that shift the weight to pointed arches and piers.
- The cathedral became a skeletal structure where walls were dissolved and replaced by stained glass windows. The objective was a buoyant, ever-increasing height that directed the eye upward.
- Deep porches on the facade were richly decorated with sculpture; twin towers were designed in proportion to the width of the facade and the rose window in the center symbolized the Virgin.
- The earliest Gothic structure was the *Abbey of St. Denis* where Abbot Suger (1137–44) had architects design the choir and ambulatory so that weight carried on pointed ribs and piers was reinforced by buttresses on the exterior. Walls were replaced by windows, and the interior was flooded with light.
- *Notre Dame Cathedral* (Paris, begun 1163) became the model of Gothic cathedrals built in France and other countries, with its majestic rectilinear design with balanced proportions of vertical and horizontal elements, a magnificent rose window placed in the center, soaring towers, deep portals, a weightless effect in the interior, and rich sculptural decoration.

Sculpture: Gothic sculpture returned to classical style. Figures are free-standing, more naturalistically proportioned, with individualized portraits. Subjects drawn from the Bible, signs of the Zodiac, labors of months, and everyday activities fill tympanums and jambs and are attached to towers, facade, exterior nave, and buttresses. Figures stand in relaxed poses creating an elegant curve.

Stained glass: The finest stained glass was made in France. Small individual pieces of colorful glass were bound together by thin strips of lead and the windows were reinforced with stone mullions and tracery. Biblical scenes, the Virgin, lives of saints, months, the zodiac, and even donors were represented in the windows.

Painting: Illustrated manuscripts such as psalters were rendered with broad areas of bright color, strong outlines, and elegant figures. Margins were often filled with intricate linear motifs in the "animal style."

Key 29 Gothic in England

OVERVIEW *Gothic captured the imagination of English architects and the style influenced their buildings down through the centuries.*

Architecture: Gothic was introduced by William of Sens, and despite French influence, the English developed their own style. Instead of standing in the center of cities, Gothic cathedrals in England were often built in grassy, treed areas. Many tend to be horizontal in orientation in contrast to the soaring verticality of cathedrals on the continent.

- Salisbury (begun 1220) has a double transept, square east end, and long choir. Typically English are the dark marble colonnettes and capitals that create a color contrast in the interior. Lancet windows dominate the screen facade while a tall needle-like spire, 404 feet high, distinguishes the cathedral.

- Gloucester (13th century) is filled with complex tracery. The strong verticals of the windows are subdivided by diagonal ribs connected with intricate crisscrossing diagonals. The choir is remodeled in the **Perpendicular Style** that corresponds to the **Flamboyant** in France.

- Chapel of Henry VII (early 16th century) in Westminster Abbey marks the culmination of the Perpendicular Style evident in the **fan vaults**, a dazzling display of triangular tracery, trefoil arches, quatrefoils, gables, etc.

- Wells Cathedral reveals the thickness and solidity related to the Anglo-Norman style, but relieved by the multiplication of Gothic moldings, shafts and ornately carved capitals. The wide, massive facade has block-like towers, a fine portal, lancet windows, and numerous sculptured figures set within pedimented niches.

- Lincoln Cathedral has a nave vaulted by a multiplicity of ribs splayed out into a complex pattern of stars purely for decorative effect (called Decorated Style). Included are double curving ogee arches and a twisted and turned intricate network of stone tracery that antedates the Flamboyant style. Here, surface ornament reached a climax and is comparable to rich embroidered vestments—an English specialty famed throughout Europe and known as "English Work."

Painting: A rare example of English Gothic painting is the *Wilton Diptych* (1377–1413). Painted in tempera, it shows Richard II as a boy with John the Baptist and Kings Edward and Edmund. Figures are slender, richly garbed, with a sensitive definition of features and realistic elements. The forms are set off by an elaborately tooled gold background. The style of the figures and the decorative quality recall the Siennese style of Duccio or Martini (Key 32) and conveys a charming and appealing spiritual scene.

Key 30 Gothic in Italy and Germany

OVERVIEW *Italian architects never fully accepted the Gothic style, and it reached Germany only in the mid 13th century.*

Italian architecture: The Gothic cathedrals of Italy lack most of the familiar Gothic features.
- The *Florence Cathedral*, a landmark of the city, was designed by Cambio in 1296. It has a vast interior, four bays long, supported on angular piers and illuminated by windows in lunettes under the vaults, a ribbed groined vault, and simplicity of decoration. On the exterior the white, green, and rose marble incrustation harmonizes with the Baptistry. The separate *Campanile* (Bell Tower) was begun by Giotto and finished by Talenti in the mid-14th century.
- The *Siena Cathedral* (late 13th century) has a striking marble facade designed by Giovanni Pisano. Distinctive are the three gabled portals, rich tracery, short turrets, and traditional basilica design.

German architecture: A widely used design in Germany was the hall church (*Hallenkirche*), in which the aisles are the same height as the nave.
- *Cologne Cathedral* was built in the French Gothic style (1248–1322) and finished in the 19th century. The interior is well proportioned vertically, and the several stories carry a cluster of towers that terminate in needle-like tracery spires.
- *Church of Saint Elizabeth* (Marburg, 1235–83) is more typical of the German hall church design, providing a more expansive, spacious interior. In the hall church flying buttresses are not needed.

Italian sculpture: Nicola Pisano, the leading Gothic sculptor, was noted for the classical-style figures carved on the pulpit of Baptistry in Pisa Cathedral. Influenced by Roman sarcophagi, he crowded his figures densely together in a shallow space. His son, Giovanni, adhered to the French Gothic style of gracefully posed figures clothed in long flowing draperies, as seen on the pulpit of Pisa Cathedral.

German sculpture: On the tympanum of Strasbourg Cathedral, *Death of the Virgin* (1220) reveals a classical touch in the flowing draperies and intense facial expressions, but the disproportion of the figures, multitude of lines, compressed space, and shared emotions are Gothic. On Bamberg Cathedral, the *Bamberg Rider* (mid 13th century) has

a rigidly posed horse, nervous and tense, while the rider is calm, handsome, and noble. A realistic note is seen in the back leg of the horse pawing the ground.

Italian painting: Giovanni Cimabue (Florence, 1280–90), in *Madonna Enthroned*, sought to break with the persistent Byzantine style, as is seen in the curved throne that suggests depth and a more fleshy Christ child seated on the lap of the monumental Madonna.

Key 31 Late Gothic

OVERVIEW *During the 14th century artistic influence flowed from Italy to France, and the merging of the two traditions led to the courtly International Style. Individual artists broke with formal traditions ands strove to depict the world around them.*

History: In the 14th century, the church, feudalism, Holy Roman Empire, authority of the papacy and guild system were weakened and eventually disappeared. Scholasticism was replaced by Nominalism, which laid the foundation for the scientific Renaissance and contributed to the Protestant Reformation. Conflicts between kings and popes resulted in the transfer of the papacy to Avignon, France, where the popes were puppets of French monarchy, and then to the Great Schism, when there were three popes at one time. This shocking event was followed by the Black Death, the bubonic plague that killed one third of the European population.

Architecture: Cathedrals in the 14th century became increasingly ornate. In France it was called Flamboyant, in England, Perpendicular.
- *St. Maclou*, Rouen, was compact with projecting portals crowned with gables that were richly decorated with a sinuous, wiry, confusing pattern of lines in Flamboyant tracery.
- In Venice, the *Doge's Palace* reveals ogival arches with flame-like tips, quatrefoils, cream and rose marble decor.

Sculpture: In France the Madonna and Child are shown in mannered, elegant S-shape curve. The complex drapery corresponds to the restless Flamboyant style. Claus Sluter in the Netherlands created figures with human dignity, tragic intensity, realistic proportions, and portrait-like features, as in the *Moses Fountain*.

Illustrated manuscripts: Book illustrations were the major form of late Gothic painting in Northern Europe.
- *Les Trés Riches Heures du Duc de Barry* (Book of Hours) by the Limbourg Brothers in the early 15th century is outstanding. Twelve calendar pages are illustrated with commonplace scenes of laborers. "February" depicts winter with a high horizon and the meticulous details of a typical farm, with the sheep crowded in the fold and peasants huddled in a cottage trying to keep warm. Outside a peasant blows on his hands for warmth, a man is chopping wood, and another leads his donkey home. Apparently these Flemish artists were influenced by Italian painters.

Key 32 Giotto, Pisano, Duccio

OVERVIEW *The increasing naturalism of these artists marks the transition from the Middle Ages to the Renaissance.*

Giotto di Bondone (1266–1336): The greatest artist of his age, he defined the future direction of Western painting. He was skilled in mosaics, painting, sculpture, and even designed the Campanile of the Florence Cathedral. In addition to panel paintings, he executed frescoes in Assisi, Padua, and Florence.

- *Madonna Enthroned* (1304) was probably influenced by classical art Giotto saw in Rome. In contrast with the same subject depicted by Cimabue, who was probably his teacher, Giotto made the Madonna a full-bodied figure with solidity and weight placed within an airy canopy and flanked by angels and prophets. The bodies of the Madonna and Christ child are revealed beneath the garments, and the figures are modeled in light and shade, giving the work a realism and humanity of conception that was unique at that time.
- *The Arena Chapel* (Padua, 1304–06), the climax of his frescoes, portrays the lives of the Virgin and Christ in a sequence of scenes.
- *Meeting of Joachim and Anna at the Golden Gate* reveals his realistic skill, sincerely expressed emotion, and concern with space, all of which tended to break with the Gothic tradition. The parents of the Virgin greet each other with ecstatic joy, people are before and within the gateway, and above is a deep blue sky. The well-modeled figures convey both expressive power and human values.
- *Lamentation Over Christ* is perhaps his finest work. Here the Virgin, lost in grief, tenderly holds the head of the dead Christ in her arms while other figures are weeping and sorrowful. Giotto created a box-like composition that was the basis of Renaissance compositions, with the figural group in the foreground balanced by the rocky ledge, leafless tree, and sky filled with weeping angels. Giotto conveyed the great tragedy in individual characterizations that the viewer could identify with.

Andrea Pisano (1270–1348): He executed the bronze doors for the Florentine Baptistry, on which scenes of the life of St. John unfolded in 28 panels framed by a Gothic quatrefoil frame. Within skillful compositions he clearly defined full forms in a shallow space that

revealed the influence of Giotto. But the gently swaying figures, flowing lines, sharp folds and gilded surfaces are Gothic. (He was not related to Nicola and Giovanni Pisano.)

Duccio di Buoninsegna (1278–1319): He best represents the tradition of Siena, where the Byzantine style was entrenched. *Betrayal of Jesus* (1309–11) consists of several scenes in one composition. The unstable figures with feet pointed downward, hovering above ground without casting a shadow, plus the stylized rocks and gold sky are Gothic. However, Duccio modeled the forms in light and shadow and gave his figures a range of human emotions.

Theme 7 15TH CENTURY IN
FLORENCE AND
FLANDERS

*F*lorence and Flanders were the major mercantile and artistic centers of Europe. The Gothic style and spirit persisted in Flanders, while the classical revival captivated Florence. Panel paintings in Flanders evolved out of Gothic manuscripts and were comparatively small in size and intricately defined. Inspired by the Roman classical past, the "discovery of the world and the discovery of man" was the Florentine revolution. Trained in architecture, sculpture, painting, and other arts, Florentines portrayed realistic forms within a mathematical perspective space. Combining classicism with the study of nature increased their artistic perception and skill. Humanists contributed to development of art theories and elevated artists to the status of educated professionals.

INDIVIDUAL KEYS IN THIS THEME	
33	Florence: 1400–1450
34	Florence: 1450–1495
35	Netherlands

Key 33 Florence: 1400–1450

OVERVIEW *Artists strove to accurately portray humans, animals, and the natural world during the Quattrocento.*

Society: Florentines, inspired by ancient classical civilizations, called their city "The New Athens." Wealthy banking families (Medici) dominated the city and were lavish patrons of art and learning. The Humanists were scholars who exalted man's dignity and intellectual achievements and strove to reconcile ancient traditions with Christian theology. Prosperity and secularism encouraged individuality and exploration in the arts and sciences. Artists excelled in many fields, sometimes signed their works, included self portraits in group compositions, and wrote both theories of art and autobiographies.

Architecture: Classical models inspired much of the building.
- Palaces for wealthy families (Medici, Pitti, Pazzi, Ruccelai) were the major monuments and were based on ancient Roman forms. Conceived as a masonry block, the palace was divided into three stories with regularly spaced arched double windows, open courtyard and a heavy overhanging roof.
- Filippo Brunelleschi (1377–1446), the foremost architect, built the dome on Florentine Cathedral; the Pazzi Chapel, scaled to human proportions, has a central plan with a dome on pendentives. The Foundling Hospital (*Ospedale degli Innocenti*), a long, low building, has a charming loggia of Corinthian columns.
- Leon Battista Alberti, who wrote about theories of art, designed the refined facade of Palazzo *Ruccellai* with superimposed Doric, Ionic and Corinthian pilasters. *Church of Sant' Andrea* has a three-story classical temple facade and central archway flanked with pilasters.

Sculpture: Increasing naturalism and an idealism based on Classical models can be seen.
- Lorenzo Ghiberti's first set of bronze doors for Florentine Baptistry (1403–24) maintained Pisano's scheme of 28 Gothic quatrefoils enclosing scenes from the life of Christ. Heavily clothed figures fill a shallow space. The second set (1425–52) portrays 10 scenes from the Old Testament within rectangular frames. Figures are small, graceful, and move easily within deep perspective space. Both doors were made in the lost wax process and gilded.

- Donatello (1386–1466) was an outstanding sculptor. *Zuccone*'s muscular body has a potential for movement while *David* was the first frankly nude male since antiquity. The equestrian bronze *Gattamelata* emulates the statue of Marcus Aurelius (See Key 19).
- Lucca Della Robbia and family excelled in glazed terra cotta figures and reliefs.

Painting: Linear perspective, invented by Brunelleschi in the 1420s, was refined by Alberti. Within a box-like space, figures are placed up front, separate from one another, with architectural and landscape elements around and behind. Depth was enhanced with aerial perspective.
- Masaccio's (1401–28) massive, weighty figures were rendered in light and dark with serious, sombre facial expressions. *Expulsion from Garden of Paradise* reveals intense psychological power.
- Paolo Uccello (1397–1475) was obsessed with linear perspective, evident in *Battle of San Romano*. He and other Florentines rendered portraits in profile bust design reminiscent of ancient Roman coins.
- Andrea del Castagno (c.1423–57), a skillful realist, depicted *The Last Supper* with Judas placed in front of the table, typical of the Quattrocento.

Key 34 Florence: 1450–1495

OVERVIEW *Despite an economic decline, there was prolific patronage of art. Artists pursued different directions during the second half of the century: scientific analysis, subjective beauty, and accurate delineation of forms.*

History: Political and economic problems increased after the death of Lorenzo de Medici (1492) and control of city by Savonarola, who denounced the sins of worldliness and paganism. In 1495 the Medici were banished from the city and their palace sacked by the troops of King Charles VIII of France.

Sculpture: Increasing realism and dramatic emotion are seen.
- Antonio Pollaiuolo's (c.1431–98) *Herakles and Antaios* is an intensely expressionistic bronze demonstrating the artist's knowledge of anatomy.
- Andrea Verracchio's (1435–88) *Bartolomeo Colleoni*, dramatically seated on a horse as he enters battle, has a disdainful, arrogant expression and powerful body. *David* exemplifies scientific study of the male nude. *Doubting St. Thomas*, as he touches the side of Christ, breaks the boundary of the niche within which the two are placed.

Painting: As the century progresses, increasing movement is seen in paintings.
- Piero Della Francesca (c.1420–92) created cool, impassive figures as in the *Legend of the True Cross* and *Madonna and Child* compositions.
- Domenico Ghirlandaio (1449–94) sacrificed spiritual concerns for a matter-of-fact effect as in *Birth of the Virgin* and *Birth of Christ*. Figures wearing contemporary fashionable garments move within a typical Florentine palace.
- Andrea Mantegna (Umbria, c.1431–1506) is noted for dramatic perspectives in *Death of Christ*, *St. James Led to Execution*, and the dazzlingly illusionistic ceiling in the Ducal Palace, Mantua.
- Pietro Perugino (Umbria, 1450–1523) in *Christ Delivering the Keys of the Kingdom to St. Peter*, composed a vast box-like stage with gracefully posed figures in foreground and smaller, accurately sized figures in the background. Architectural buildings are imaginative classical and Renaissance models.
- Luca Signorelli (Umbria, c.1445–1523) portrayed straining, twisted figures in complex composition, *The Damned Cast into*

Hell. The fleshy, muscular figures influenced Michelangelo (See Key 39).

- Sandro Botticelli's (1444–1510) Neoplatonism is reflected in the expressionless, beautiful faces and idealized rhythmic forms in *Primavera*. *The Birth of Venus* is based on a Hellenistic Aphrodite statue. Captivated by the preaching of Savonarola, Botticelli in his later works rejected classicism for the Gothic style, evident in distorted figures, flattened compositions, and intense expressions of anguish as in *Lamentation* and *Adoration of Christ*.

Key 35 Netherlands

OVERVIEW *There was little or no interest in classical antiquity or the pursuit of a new style. Painting evolved out of the late middle ages with a heightened interest in accurately recording the world. No significant architecture or sculpture was produced.*

History: Ruled by Burgundy, the Netherlands was the largest flourishing urban center in Northern Europe. The merchant class gained in importance as the power of the feudal nobility declined.

Painting: Painted panels and altarpieces exemplify the meticulous details and brilliant color inspired by manuscript illumination. Artists perfected the technique of oil painting and filled their scenes with iconographic symbols.

- The Master of Flémalle (Robert Campin, c.1378–1444) in *The Annunciation* portrays a Biblical event set within a contemporary room. Typical are the steeply pitched floor, slender figures completely enveloped with heavy garments, pious solemn expressions and exquisite details.
- Jan and Hubert Van Eyck (c.1390–1441), the most outstanding artists, vividly displayed the extraordinary range and brilliance of oil technique and style in *The Ghent Altarpiece*. Panels depict Adam and Eve, Adoration of the Lamb, Christ, the Virgin, St. John, donors, musicians, a procession of figures, and intricate landscape with a wealth of minute details. Jan Van Eyck's *Giovanni Arnolfini and His Bride* is rendered with consummate skill from the reflective mirror on the far wall and inscription of artist to the numerous meticulously presented symbols, including the lighted candle, dog, and discarded sandals.
- Roger Van Der Weyden (c.1400–64) portrayed religious scenes with intense mysticism and Christian drama. His portrait figures are posed in three-quarter view and reveal refined, delicate modeling and an aristocratic air.
- Hugo van der Goes (c.1440–82) in the *Portinari Altarpiece* portrayed the nativity, with the donors and their patron saints. Portraits of the Portinari family on the two wings are overwhelmed by large-size patron saints symbolic of their importance. The same scaling is found in the central panel, where the Virgin and Joseph are taller than the adoring shepherds. In contrast to the solemnity of the Holy Family, the shepherds are animated and shown in realistic detail.

Theme 8 16TH CENTURY IN ITALY

*H*igh Renaissance, Mannerism, and Early Baroque distinguished the 16th century in Italy. The Papacy, a political power and leading patron of the arts, commissioned the foremost architects, sculptors, and painters for works that glorified the Vatican and Holy City. Artists achieved a god-like status and mingled with the great minds of the age. Human images took on an impressive grandeur, perfection, and beauty that was unparalleled in Western art. Italy soon came in conflict with Francis I of France and Emperor Charles who sacked Rome in 1527. The Reformation (1517), ignited by Martin Luther, rapidly spread and by mid century one fourth of the population in Europe was Protestant. Political and religious upheavals, economic decline, and social crises in Rome and Florence contributed to the complex, distorted forms of Mannerism, 1520–90. By the end of the century, Venetian artists created a colorful, dynamic, Early Baroque style that influenced the 17th century.

INDIVIDUAL KEYS IN THIS THEME

36	High Renaissance
37	Leonardo da Vinci
38	Michelangelo
39	Venice
40	Titian
41	Mannerism
42	El Greco

PLATTE COLLEGE RESOURCE CENTER

Key 36 High Renaissance

OVERVIEW *After the upheaval in Florence, artists flocked to Rome to work for the popes, who strove to make the city the spiritual and artistic center of Europe. During this turbulent age, marked by foreign invasion, militaristic expansion under Pope Julius II, and the Reformation, artists created the magnificent, refined, heroic style of the High Renaissance. Balance, serenity, perfection, and beauty of forms characterize the High Renaissance.*

Donato Bramante (1444–1514): He designed the *Tempietto* (site of St. Peter's martyrdom) as a circular peristyle structure based on the Roman tholos with a frieze, balustrade, and central dome. In 1506 he was commissioned to remove Old St. Peter's Church (See Key 20) to make way for the new St. Peter's. Bramante was one of 14 architects who worked almost a century and a half for 20 popes before St. Peter's was completed. He conceived of a central plan crowned with a high dome and surrounded by smaller domes above the four equal arms. The dome was built according to Michelangelo's designs, and in the 17th century the nave was lengthened to conform to the Gothic plan.

Raphael Sanzio (1483–1520): Exemplifying the High Renaissance man in his intelligence, artistic achievement in many fields, refinement, and physical beauty, Raphael was the head of a brilliant society at the papal court. A student of Perugino, he was influenced in Rome by the work of Michelangelo and da Vinci and created images that emulated the perfection of ancient Greece.
- The composition and figural group of *The Marriage of the Virgin* (1504) was borrowed from Perugino's *Christ Giving the Keys of the Kingdom to St. Peter*, but Raphael compressed the figures into a harmonious group within a vast space dominated by a Tempietto-like building in the background.
- On the walls of the Vatican he painted large frescoes—allegories of Philosophy, Theology, Justice and Poetry. *The School of Athens* shows Plato and Aristotle on the top step framed by an open doorway and surrounded with a symmetrically arranged host of ancient scientists within a spacious, ornate, vaulted nave reminiscent of Bramante's (his uncle) plan for St. Peter's Cathedral as well as of Roman baths.

- In Stanza d' Eliodora, in scenes such as *The Expulsion of Heliodorus*, he also reveals the explosive power of Michelangelo.
- In a series of Madonnas, like *Madonna with Goldfinch* (1505–6), the pyramidal composition is based on da Vinci and the forms defined with sharp contours, bright colors, and diffused light that combines the Christian spirit with pagan beauty.
- Typical of Raphael's superb portraits is *Count Castiglione*, in which the author is portrayed as the civilized, cultivated ideal man of the Renaissance that he described in *The Courtier*. The composition is based on the Mona Lisa.

Michelangelo: Michelangelo's *Sistine Ceiling* frescoes (1508–12) portray scenes from the Book of Genesis in three architectural zones. The main central zone has nine panels flanked by architectural elements and filled with prophets and sibyls; in spandrels are ancestors of Christ and Virgin. Michelangelo began painting at the entrance, with *The Drunkenness of Noah*, and as he progressed towards the altar, forms took on a grandiose sweeping power like that of his carvings in stone. (Also see Key 38.)

Key 37 Leonardo da Vinci

OVERVIEW *Leonardo da Vinci (1452–1514), more than any other artist, best approaches the Universal Man of the Renaissance. He was a painter, sculptor, architect, inventor, engineer, musician, physicist, botanist, anatomist, geologist, and geographer.*

***Annunciation*:** An early work, it adheres to the Early Renaissance style in the box-like space, clarity of light, linear definition of forms, and separate, individual treatment of the angel, Virgin, building, and landscape elements.

Adoration of the Magi (1481–82): Developed from numerous sketches, it was never finished. In the center are the Madonna and Child, surrounded by adoring figures, all bound together and modeled as three dimensional forms. Gestures and faces convey an intense emotional quality.

Virgin of the Rocks (1485): In this further development of da Vinci's innovative composition and style, the three figures are arranged in a triangular composition that dominates the center. They are rendered as gracefully posed forms in a poetic, classical spirit. A pervasive sfumato erases all lines and gives the forms a heavy, full-bodied quality. Behind is the typical da Vinci grotto, drenched in shadow that blends with the figures. Unlike the clearly separated figures of Early Renaissance painting, the figures here are unified both with each other and with the space that surrounds them.

The Last Supper (1495–8): This fresco began to deteriorate soon after its completion because da Vinci had attempted to combine oil and tempera in the medium. It has been so heavily overpainted and restored that little remains of the artist's hand. Within a deep, spacious room, a long table dominated by Christ at the center is accentuated by the central vanishing point and open window behind. Christ's passive, compassionate expression is in dramatic contrast to the apostles, arranged in groups of three. For the first time, Judas, instead of being in front of the table, becomes a part of one of the groups.

Mona Lisa (1503–5): The world famous woman with idealized features, enigmatic smile, and a warm, tender, and appealing expression is posed in a triangular composition. Typical of da Vinci are the sfumato and the strange rocky cliffs and river in the background. The pose and

style of the *Mona Lisa* exerted a tremendous impact on many artists of the High Renaissance and subsequent centuries.

Drawings: Da Vinci drew a remarkable number of studies of dissections, such as *Embryo in the Womb* (1510), with analytic accuracy. He also made hundreds of pen and ink drawings of human anatomy, rocks, water, birds, animals, and the world of nature as well as of inventions like the machine gun, submarine, airplane, etc.

Key 38 Michelangelo

OVERVIEW *Michelangelo Buonarroti (1475–1564) thought of himself as a sculptor who had the divine power to create the image of man. He attacked the block as if to free the image locked within the stone. His titanic forms, expressive strength, and tragic grandeur has been described as "terribilità." His style evolved from Early to High Renaissance to Mannerism.*

Pietà: This early work exemplifies the Early Renaissance in its compact design, slender form, elaborate drapery, and descriptive details.

David: The classical stance, powerfully muscled body, potential movement, and proud, intense expression represent the glory of the High Renaissance. A colossal figure (14'3"), David watches the approach of Goliath with pent-up passion.

Tomb of Pope Julius II: It was conceived as free-standing monument with more than 28 statues, but only about one third were completed. The design of the tomb is similar to the plan of Sistine Ceiling; Moses recalls the image of God while the bound captives recall the nudes depicted on the ceiling. The dramatic contrapposto of the figures was influenced by the discovery of the Hellenistic *Laokoön* statue (Key 15).

Tombs of Giuliano and Lorenzo de Medici: These twin tombs in Lorenzo Chapel represent the active and contemplative life. Giuliano is alert, clothed in Roman armor, with images of Night and Day reclining on the tomb before him. Lorenzo is deep in thought, with Dusk and Dawn placed on his tomb.

Deposition (1540): Here the dead Christ, supported by four figures, is shown in a twisted, limp, serpentine pose; the figures behind are roughly blocked out. The whole is Mannerist in style.

Architecture: The tensions of the statues are also felt in Michelangelo's architecture.
- *The Laurentian Library* consists of two stories with superimposed orders, a huge staircase with bow-shaped steps extending outward (the first time a staircase became major interior architectural element), and patterns of dark and light stone.
- *The Capitoline Hill*, an impressive piece of city planning, was commissioned by Pope Paul III. Michelangelo laid out the vast circular space of the Campidoglio, decorated in a geometric design

(cosmological), and the base for the statue of Marcus Aurelius. New facades with Corinthian pilasters enhanced the facades of the Palazzo dei Senatore, the Palazzo dei Conservatori, and a new building (completed in the mid-17th century) that gave the piazza a trapezoidal shape.

- The *Farnese Palace* was the largest private palace in Rome. Michelangelo designed the grand cornice and the arms above the central windows and improved walls and windows in the courtyard.
- The great *Dome of St. Peter*'s is accentuated by a giant order of columns; paired columns serve as buttresses for the hemispherical dome with its large ornamental lantern.

Painting: *The Last Judgment*, behind the altar of the Sistine Chapel, shows the second coming of Christ surrounded by apostles, the Virgin, swarming figures who soar up to heaven, and others who surrender and are pulled down to hell. The multitude of distorted figures, totally filling the space, is typical of Mannerism.

Key 39 Venice

OVERVIEW *The republican empire of Venice, governed by successful merchants, grew prosperous from an extensive network of trade. The Doge, merely a figurehead, was ensconced in a luxurious palace on the Grand Canal, a thoroughfare lined with magnificent palaces and public buildings. Free of despotic rulers, Venetian artists explored new dimensions in the visual arts.*

Architecture: Venice called on foreign masters from other cities, particularly Lombardy.
- Sansovino (1486–1570) designed the Library of San Marco with two superimposed arcades of Doric and Ionic orders decorated with putti supporting garlands.
- Andrea Palladio (1808–80), the greatest architect of the city, influenced many 18th century architects such as Thomas Jefferson. He is noted for the *Villa Rotunda*, a summer retreat built on hilltop above Vincenza. It has four identical projecting porches, balustrades, Ionic facades, central crowning dome, and statues on the roof.

Painting: Venetian painters used canvas, flexible resins, glazes, and rich, glowing oil pigments. Luminous landscapes and brilliant, exuberant scenes reflected the festive spirit and wealth of the city.
- Giovanni Bellini (1430–1516) created the Venetian style. Influenced by Mantegna and the oil technique introduced into the city by Messina, he portrayed glowing colorful forms bathed in atmospheric light. *The Feast of the Gods* shows peasants representing Greek deities with satyrs, partly nude nymphs, and fully dressed men in an idyllic setting.
- Giorgione de Castel Franco (1478–1510) portrayed fleshy nude nymphs in a landscape with two fully dressed men (possibly the nymphs represent muses) in *Pastoral Symphony*. His *Sleeping Venus*, with the reclining nude placed in the foreground of a bucolic landscape, was finished by Titian.
- Tintoretto (1518–94) was the most dramatic and powerful painter of religious themes in Venice. His style evolved from the High Renaissance through Mannerism to Early Baroque. *Finding of the Body of St. Mark* (1562–66) represents the Early Baroque in the dynamic diagonals, vivid contrasts of dark and light, muscular animated figures, and the theatrical effect of figures hurtling

through space. *Bacchus and Ariadne* (1577) reflects Copernican theories of space in the sweeping arrangement of heavy forms within a circular pattern that shatters the box-like space of the Renaissance. *The Last Supper* (1594) is Mannerist in the inter-relationship of turbulent heavens and earth, the sharp perspective of the table with Christ and the apostles, the separate groups of figures, and the confusion of the scene.

- Veronese (1528–88) portrayed the pomp and splendor of Venice in *Christ in the House of Levi*. Christ and the apostles are seated behind a table and surrounded with grandly garbed people; magnificent marble arches fill the background. *The Triumph of Venice* (1585), in the Doge's Palace, is a powerful, illusionistic ceiling painting within an oval frame. The complex perspective at a 45 degree angle to viewer, twisted columns, massive, dramatic figures, and contrasting colors represent the Baroque style and influenced later artists such as Tiepolo.

Key 40 Titian

OVERVIEW *Titian (1490–1576) was a prolific and highly sought after artist who exerted a tremendous impact on Western painting. A superb colorist, he applied up to forty layers of glaze that contributed to the warm lustrous glow of his canvases.*

Sacred And Profane Love (1515): Two women, one lavishly clothed and one nude, sit on a sarcophagus in a bucolic landscape. The contrast between the lustrous satins and the fleshy buxom nude is enhanced by the textural background.

Madonna of the Pesaro Family (1519–26): The huge 16-foot canvas is an example of Titian's fully formed style. Bishop Pesaro, who led a successful expedition against the Turks, kneels before the Madonna and Child, who are elevated on a high throne. Saints, Turks, Pesaro, and his family crowd the lower part of the composition. Massive columns, spirited figures, and dramatic clouds with cupids; the diagonal, asymmetrical design; and the rich surface textures and vivid colors characterize the operatic spirit of Venetian painting that led to the Early Baroque.

Venus of Urbino (1538): In this painting, influenced by a similar work by Giorgione, Venus reclines on a white and red couch that sets off the ivory glow of her flesh. Her sensuous form is accentuated by the dark red drape behind her; the spacious room has an open vista in which two servants can be seen. The organized composition, color, harmonies, and luxuriousness of the scene are typical of Titian.

Man with the Glove (1519): Here Titian's superb skill as a portraitist can be seen. The half-length figure is seemingly pulled out of the dark background by the accents of light on his head, white shirt, and hands—one holds drapery, the other clutches a glove. The commanding, impressive figure, both meditative and preoccupied, embodies the High Renaissance courtier described by Castiglione.

Christ Crowned with Thorns (1575): Titian's later style, seen here, leads to the 17th century Baroque. The large figures of Christ and the tormenting soldiers fill the foreground. The twisted, animated figures are emphasized by the strong play of lights and darks; they are cast against a mysterious, undefined background, giving the scene a supernatural quality. The brushstroke is loose and broad. Titian's heavy **impasto** was adopted by Baroque painters.

Key 41 Mannerism

OVERVIEW *Mannerism evolved in Florence and Rome about 1520–1600 against a background of political, economic, and religious upheaval. Artists working in the style or "manner" of Raphael, da Vinci, and Michelangelo sought to develop a purely personal style not based on the study of nature.*

Characteristics: Emphasis was placed on imagination, eccentricities, versatility, and individual expression; classical harmony was rejected.

Giulio Romano's *Palazzo del Tè* (Mantua): The long, low, ambiguous design of the first and second stories, irregular pairing of pilasters, syncopated pattern of triglyphs, and blind pedimented windows violate all principles of Renaissance architecture.

Sansovino's Wing on Library of St. Mark (Venice): The alternating pediments in semicircular and triangular shapes are surmounted with unstable seated nude statues.

Sculpture: Bologna's *Mercury*, a massive, muscular nude, hovers in space supported only on the toes of one foot. *The Rape of the Sabine Women* is a writhing form of three figures who soar upward in a spiral motion.

Jacopo Pontormo (1494–1556): *Joseph in Egypt* has restricted space, anatomical distortion of unrelated groups of figures, a staircase that leads nowhere, and irrational lighting. In *Descent from the Cross*, the compressed space, piled-up figures, clashing colors, darkened background, and expressions ranging from fear to detachment to anger are all Mannerist.

Parmigianino (1503–40): *Madonna of the Long Neck* is exaggerated, with forced elegance and sweetness, and is placed within a disturbingly illogical space. *Cupid Carving the Bow* (1530) is a long, slender form that looms large on the picture plane. Huddled below are Psyche and a young Cupid. The double representation of the form in the same composition plus the distortion of the figures is typically Mannerist.

Bronzino (1503–73): *Eleanor of Toledo and Her Son Giovanni de Medici* is Mannerist in the glassy, almost enameled surfaces, preci-

sion of linear patterns, limited modeling, restricted depth, elegant effect, and strange, disturbed mood.

Giorgio Vasari (1511–75): His painting *Lorenzo the Magnificent* is based on Michelangelo's sculpture. Lorenzo, painted half length, almost totally fills the composition. His hands are overly large, and he is surrounded with masks symbolic of the classic past. The dense, crowded forms, play of lights, and the dark and nervous linear pattern all exemplify Mannerism.

Key 42 El Greco

OVERVIEW *El Greco (1574–1614), a Mannerist, was born on Crete, where he was influenced by Byzantine art. He worked in Venice and Rome before settling in Toledo. His style was so personal and powerful that he really had no followers. His art was forgotten after his death only to be "rediscovered" by Manet, Cezanne, and Picasso.*

Early work: These paintings reflect the influence of his Italian studies.
- *Cardinal Clovis* (1590) is portrayed in three-quarter pose holding an open book with an illustration of a Titian painting. The landscape seen through the open window is Venetian in color and brushstroke.
- *Christ Driving the Money Changers from the Temple* uses the distorted Mannerist space and Venetian color; the figures recall Michelangelo and Raphael.
- *Pietà* is based on Michelangelo's late sculptural group; the influence is evident in the muscular attenuated figure of Christ and the expressive supporting figures.

Mature work: Exalted emotionalism is characteristic of this period.
- *Espolio* uses the Mannerist shallow space with crowded figures. Christ is rendered in the heroic style of Michelangelo; the small head and large dark eyes recall Byzantine conventions. His red robe recalls the rich Venetian color. This was one of several paintings that disturbed the clergy. They vainly pressured El Greco to modify the composition and make the image of Christ more dominant.
- *Burial of Count Orgaz* (1586) shows a miraculous event that El Greco rendered in profoundly spiritual terms, assimilating Venetian color and Byzantine forms in an overwhelming mysticism. An angel gingerly carries the cloud-like soul of the count up to heaven, where Christ, St. John, and the Virgin are seated on clouds. Heaven and earth flow into one another in this flattened, tapestry-like mural; the realistic portraits of the observers contrast with the attenuated proportions of the spiritual forms.
- *Grand Inquisitor Don Fernando Nino de Guevara* (1600) exemplifies El Greco's penetrating portrait style. The leader of the Inquisition assumes a Venetian pose, and his crimson robe is rendered in swift brushstrokes. His intense, piercing gaze captures the awesome power of this feared religious leader.

Late work: El Greco created paintings composed of intense color and light, pattern and movement, and with no reference to the art of the past or present.

- *Resurrection* (1597–1604) is typical of El Greco's late work in the tall, elongated figure of Christ, holding a staff with white flag and set against a dark background. The twisted, disproportionate forms of the soldiers seem to be pulled upward in a powerful movement that contrasts with the calm expression of Christ.

- *View of Toledo* (1600–1610) a dynamic composition of cool colors—blues, grays, greens—is one of the most remarkable independent landscapes in Western painting. The hilly terrain in the foreground winds toward the city, where the cathedral spire points upward to the only blue patch in a dramatic and stormy sky.

- *Vision of the Opening of the Fifth Seal* (1601–14), one of El Greco's last works, illustrates the tremendous visionary poetry of Revelations. St. John's eyes turned to heaven symbolize ''a living flame striving upwards'' in an apocalyptical vision of color, light, and movement.

Theme 9 16TH CENTURY IN
NORTHERN EUROPE

*T*he Italian Renaissance style first crossed the Alps by means of illustrated manuscripts and books of classical texts and engravings of mythological subjects. These were followed by the Italian artists themselves, who worked for kings and courts. Northern artists, in turn, traveled to Italy to observe classical art. In Germany the printing press stimulated the use of graphic arts in printed texts; Dürer created the Northern equivalent of the Italian Renaissance style. The Flemish Brueghal, who was part of the intellectual circle of Antwerp, traveled to Italy but was not impressed by what he saw. In France, where the influence of Italian art was overpowering, Francis I brought Renaissance and Mannerist artists to his court to glorify both the state and himself.

INDIVIDUAL KEYS IN THIS THEME

43 Netherlands and France

44 Germany

Key 43 Netherlands and France

OVERVIEW *The revolt of the Netherlands and the impact of the Reformation left the Netherlands split into the Catholic south (Belgium), under the rule of Spain, and the Protestant and independent north (Holland). France, unified by powerful kings, hosted Italian artists like da Vinci and the Mannerists.*

Netherlands painting: Pieter Bruegel (c.1525–69), the most original artist, worked for merchants in Antwerp and Brussels. He was unimpressed by the Italian Renaissance.
- Bruegel focused on the life of peasants and the moods of nature. *Hunters in the Snow*, one of a series on the seasons, uses the high horizon, details of distant towns, and the bulky forms of hunters.
- *Peasant Dance* satirizes the gluttony and lust of peasants. *Massacre of the Innocents* allegorically shows the atrocities of Spanish troops subduing a rebellion. *Parable of the Blind* symbolized the declining fortunes of his country. In these and other paintings, Bruegel recorded the suffering of his age.

French painting: Jean Clouet (c.1485–1514), the major artist, combines French and Italian Mannerist styles in his *Portrait of Francis I.* Il Rosso and Primaticcio decorated the gallery of the royal palace at Fontainebleau with Mannerist paintings, frescoes, simulated mosaics, and sculpture.

French architecture: Grand châteaux built along the Loire River served as country houses and hunting lodges for royalty.
- *Chambord*, laid out on a vast scale with formal gardens, combines Italian classical concepts with decorative French Gothic elements.
- Pierre Lescot (1510–78), under Henry II, designed a wing for the *Louvre*. Typical of the age, the wing combines superimposed classical orders with Gothic traits.

French sculpture: A combination of Mannerist and earlier styles is characteristic.
- Jean Goujon's (c.1510–65) stone reliefs of classical goddesses, with Hellenistic wet drapery, assume twisted Mannerist poses.
- Germain Pilon (c.1535–90), a powerful sculptor, blended Mannerist and ancient forms. He made monumental tombs for Henry II and Catherine de Medici. Bronze figures of the king and queen appear twice—once praying and once as corpses. The queen is portrayed as Venus, and the king as Christ.

Key 44 Germany

OVERVIEW *Painting was the major art form of this period.*

History: Germany was a loose collection of principalities, duchies, bishoprics, and city states controlled by clergy, powerful dukes, and banking families like the Fuggers. Italian humanism infiltrated the country at the turn of the century through writers like Erasmus and Luther. A series of peasant revolts raged throughout the century.

Matthias Grünewald (c.1480–1528): He exemplified the emotionally charged and expressive German style. *The Crucifixion* on the Isenheim Altarpiece shows the tortured body of Christ nailed to the cross. The weight of His body dislocates all his joints. His scourged flesh is gangrenous, and blood pours from the nail driven into His feet. His mouth is open as the last breath escapes, and His pointed fingers are convulsed and angular. A forlorn, dark, and menacing background underlines the anguish of the event.

Albrecht Dürer (Nuremburg, 1471–1528): The outstanding German artist, he was influenced by the Italian Renaissance. A superb graphic artist, he perfected a precision of line that distinguished his paintings.
- *Self Portrait* recalls the *Mona Lisa* (Key 37) but is defined by a wire-hard line. In another *Self-Portrait* Dürer appears as a Christ image.
- *The Four Apostles* have the heavy, bulky forms and intense expressions that convey an inner drama.
- Stylistically, Dürer defined sharp, unflattering features on his faces and captured the textural qualities of furs, wool, hair, and skin. He also painted landscapes.

Lucas Cranach (1472–1553): He combined Gothic and Mannerist elements in *The Judgment of Paris*. The elaborately detailed costume of the knight is typical of the late Middle Ages; the three curvaceous nudes recall the International Style; and the all-over incongruity is Mannerist. A series of Venus nudes reveals the same stylization combined with provocative smiles.

Albrecht Altdorfer (c.1480–1538): His religious and mythological scenes set in the Danube Valley are among the first landscapes painted. He recorded the forms of nature as an illustration of God's creation. In *The Battle of Issus*, a vast space with a high horizon is filled with a multitude of tiny, swarming figures, rendered in meticulous detail.

Hans Holbein (1497–1543): He emigrated to London during the religious conflicts and was appointed court painter to Henry VIII. He painted such leading humanists as Erasmus and Thomas More. Stylistically, the figures are heavy, bulky, and fill the space. The materials are richly textured and detailed, while the faces are defined with a sensitive line and little modeling. His later portraits are flattened, disproportionate, and Mannerist.

Theme 10 17TH CENTURY

*T*his was an age of powerful, wealthy nations. The Netherlands remained divided into Spanish-dominated, Catholic Flanders and independent, Protestant Holland. France, the largest and most prosperous nation, was governed by the sun king, Louis XIV. England was the foremost maritime power. Major discoveries and advances were made in science, and the complex political and intellectual developments were recorded artistically in several styles. The dramatic Baroque reflected the goals of the Catholic Church and great kings. The classical Baroque was inspired by the stable, ordered Italian tradition. Naturalistic small-scale themes distinguished the Dutch Baroque. Art academies flourished. To create large-scale works on canvas and ceilings, artist workshops had many assistants. Writings on art and art criticism proliferated and the self confidence enjoyed by artists was reflected in the growing number of self portraits.

INDIVIDUAL KEYS IN THIS THEME	
45	Rome
46	Caravaggio
47	Spain
48	France
49	Flanders
50	Holland
51	Rembrandt and Hals
52	England and America

Key 45 Rome

OVERVIEW *In its efforts to counter the Reformation, the Roman Catholic Church encouraged visual forms that appealed to the senses and excited religious feeling. Artists portrayed miracles with drama and realism.*

Francesco Borromini (1599–1667): For *San Carlo Alle Quattro Fontane*, he broke with the block-like Renaissance shape to design a facade with elastic concave and convex shapes intended to produce both a sense of instability and ecstatic meditation.

Gianlorenzo Bernini (1598–1680): This architect, painter, sculptor, and poet dominated Rome and changed the face of the city more than any other artist.

- His Entrance Piazza of St. Peter's Cathedral has a monumental Tuscan colonnade of Doric columns that explodes out of the facade in great sweeping curves that were, he said, "Motherly arms of the Church embracing Catholics."
- Within the Cathedral he constructed the *baldachinno*, the canopy above the main altar, with huge twisted columns that were supposedly based on those in Solomon's Temple in Jerusalem. Above, buoyant scrolls and dynamic carved figures exemplified the flamboyance of the Baroque.
- *Fountain of Four Rivers* (1648–51, Piazza Navona) has, at the base of an obelisk, four gigantic, powerful, muscular figures caught in split-second movement. They personify the Church's triumph over the world, while the rock in the center symbolized Cavalry Hill.
- *The Ecstasy of St. Theresa* was designed as an environment, and the figures seem to hover on marble clouds. The angel recalls a Cupid by Correggio; the saint's head is thrown back, eyes closed and mouth open in convulsive ecstasy. Contemporaries were disturbed by this almost sensuous image.
- *Francesco I d'Este* (1651) demonstrates Bernini's skill at portraiture. He captured the haughty spirit of the sitter with the Baroque dynamic pose of twisted head and shoulders and heavy folds of drapery sweeping downward and upward as if carried by a forceful wind. This bust shows Bernini's technical virtuosity and power.

Artemisia Gentileschi: The leading woman painter, she was influenced by Caravaggio (Key 46) and portrayed religious themes like *Judith and Holofernes* with inner drama, active poses, and exotic mystery accentuated by candlelight.

Fra Andrea Pozzo (1642–1709): He captured the Baroque spirit in explosive murals like the Ceiling of Saint Ignazio, where all parts are combined into a single indissoluble whole as a multitude of forms fly within a limitless space. He dissolved walls, ceiling, and dome into an illusionistic vista.

Annibale Carracci (Bologna 1560–1609)): He decorated the Farnese Palace gallery in a vigorous and sinuous Michelangelesque style. In *Love of Gods*, a huge muscular nude was the principal motif.

Key 46 Caravaggio

OVERVIEW *Caravaggio's (1571–1610) rebellious way of life was comparable to the revolutionary impact he had on 17th century art.*

Style: He emphasized powerful sensation instead of the intellectual and classical ideals of Italian art. Scorning the traditional and focusing on nature, he sought to record the appearance of things at a specific time and in a given place and combined an intense feeling for the drama of light with a meticulous accuracy of forms and textures. His followers in Italy were known as the "Caravaggisti."

Bacchus (1590s): Bacchus is portrayed not as a classical god but as a young boy with a plump face, fleshy torso, and realistic features. The lack of modeling in light and shade reveals a trace of Mannerism.

Cardsharper (1595): Caravaggio's dramatic grouping of figures and intense chiaroscuro intensify the actuality of the moment and the suspended animation as one figure is caught in the act of getting up from his chair.

Calling of St. Matthew (1597–8): The figures playing cards at a table in an ordinary Roman tavern suddenly stop and look up in surprise at the miraculous apparition of Christ hidden in the shadows. A beam of light pouring through a small window illuminates the hand of Christ pointing to St. Matthew, reminiscent of Michelangelo's *Creation of Adam* on the Sistine Ceiling. The dramatic contrast of light and dark draws the viewer into the scene. The idealization of the Renaissance is replaced by the visual accuracy and theatrical immediacy of the event.

Entombment of Christ (1602–4): The massive figures and Nicodemus holding the body of Christ dominate the composition and are modeled with intense patterns of light. Behind are the shadowed heads of St. John and The Three Marys. The dynamic movement of the forms overwhelms the viewer.

David with the Head of Goliath (1606): The deep shadows, convincing foreshortening, and remarkable realism are characteristic of Caravaggio. The soft, gentle face of David emerges from a dense black background. The youth is bareheaded and wears a commonplace white shirt. Clutched in his hand is the hair of Goliath's head with blood streaming down. (Goliath may be a self-portrait of Caravaggio.)

Death of the Virgin: Here Caravaggio humanized the event within a small room. The apostles gathered around the bier of the Virgin express a wide range of emotions. The Virgin wears humble clothes and Her feet are exposed. The dark background is broken up by a Venetian-type red curtain, and a beam of light illuminates the figures.

Key 47 Spain

OVERVIEW *Foreign influence and Moorish traditions were replaced by the national inspiration that made the 17th century the Golden Age of Spain. Extreme religious intensity existed side by side with extreme moral corruption.*

History: Philip II unified Spain and ruled as absolute monarch. He established the capital at Madrid and with the vast wealth from the Americas he built the Escorial, which symbolized the grandeur of his reign. Political power declined under Philip III and Philip IV.

Architecture: The *Escorial*, designed by Juan Bautista and Juan de Herrera, is on the site where St. Lawrence was believed to have been martyred. A vast quadrangle, 500,000 square feet, it includes a palace, monastery, college, archive, church, and other buildings and reflects the grandeur of the Baroque age. The Plateresque (related to ornate silverwork) and Churrigueresque (named after the designer José Churriguera) styles of architecture were florid and richly elaborate. Their emotional excesses were a reaction against the severity of the Escorial.

Diego Velásquez (1599–1660): This master of naturalism served as court painter to Philip IV. He had a close relationship with the king and served as marshall of the palace.

- His early style, seen in *The Water Seller*, represents the "bodegones" of commonplace themes, with Caravaggesque chiaroscuro, detached naturalism, heavy pigment, and a limited palette of earth colors. *The Drinkers* shows Bacchus as a playful youth surrounded by a rugged, individualized peasants. Also a superb portrait painter, Velásquez portrayed the king in a dark costume cast against neutral background.
- After a trip to Venice (1629) at the urging of Rubens, he came under influence of Titian. This can be seen in the rich colors, spacious landscapes, and subtle tonality of the portraits of the King, Don Carlos, and Olivares. In *The Surrender of Breda* brighter colors and deep space give the figures an ease and freedom.
- His second trip to Venice (1649) led to a lighter, more subtle gradation of tone, seen in *Las Meninas*. Within a large room Velásquez himself, standing before a monumental canvas, works on a portrait of the royal children. The king and queen are seen in reflection in a mirror on the back wall. A courtier framed in the

doorway is painted in almost impressionistic style. Velásquez reduced the solid forms to optical sensations of color tones in a purely painterly style that is startlingly real.

Francisco de Zurbarán (1598–1664): His best known paintings are those of saints in devotional attitudes sharply lighted from one side within a darkened space. *St. Francis in Meditation*, for example, shows the saint clutching a skull—symbol of the transience of life. The stark light and dark, bare setting set off the image of an entranced soul in intense meditation, characteristic of Catholic Spain.

Bartolomé Estéban Murillo (c.1617–82): His large workshop in Seville produced many canvases of the Immaculate Conception, where the young Virgin is shown in a popular, sentimental style. Holy Family scenes have a charming ''Raphaelesque'' quality.

José de Ribera (1591–1652): After settling in the Spanish province of Naples, he came under the influence of Caravaggio. *The Martyrdom of St. Bartholomew* shows, in harsh realism, the great pain and fear on the face of the saint as executioners strain to raise the cross on which he is nailed.

Key 48 France

OVERVIEW *Louis XIV dominated Europe (1660–1715) and Paris replaced Rome as the major art center. Politically and culturally, French influence was supreme. Academies established standards and regularized style and taste in all the arts. A stately classicism distinguished French art from the Baroque emotionalism popular in other countries.*

Architecture: Classicism prevailed over Italian Baroque.
- Mansart designed the *Church of the Invalides* with bold dome, pediments, and columns that create light and dark patterns on the facade.
- Perrault, Le Vau and Le Brun added wings to the Louvre with a mix of Italian and French classical elements that gave it grandeur and monumentality.
- Le Brun directed construction of Versailles—symbol of the absolute power of Louis XIV—assisted by an army of architects, decorators, sculptors, painters, and landscape designers. Built on a monumental scale, it housed government and military officials, courtiers, and servants in its more than 100 rooms. The bedroom of the king also served as audience chamber and was the center of the plan—all avenues led towards it. It has a classical Roman facade, three levels of colonnades, and lavish interior decoration, particularly in the *Hall of Mirrors*.

Sculpture: Girardon's model for equestrian statues of Louis XIV show the "wind-blown" movement typical of the Baroque. The influence of Bernini can be seen in Puget's *Milo of Crotona*, with its powerfully muscled, contrapposto forms.

Nicolas Poussin (1594–1665): He lived most of his life in Rome and was a classicist noted for grandly serene and ordered compositions. Influenced by Raphael and Titian, he portrayed groups of figures within large landscapes composed of interlocking terraces and flanked by a pattern of tall dark trees. He believed great subjects were the basis in creation of great art.

Claude Lorraine (1600–82): Although he worked in Rome with Poussin, he was not interested in ancient themes. Instead he focused on moods of nature like the setting and rising of the sun. His compositions generally have a broad sky, vast fields or sea shore, all bathed in the golden light of dawn or sunset.

Georges de la Tour (1593–1652): He painted religious themes in the Caravaggesque manner, as *Lamentation over St. Sebastian*, in which the saint lies pierced with arrows in a room illuminated only by torch light. Forms are simplified, and the absence of surface details creates a calm, classical stability.

Louis Le Nain (c.1593–1648): His peasants are portrayed in the Dutch manner, but Le Nain emphasized their hard work, honesty, and suffering during The Thirty Years War. They appear resigned and stoic.

Key 49 Flanders

OVERVIEW *Flanders remained under the control of Spanish rulers, who encouraged learning and the arts while commerce stagnated and economic difficulties erupted. It was not an age conducive to large scale building or sculpture; the glory of Flemish art is the paintings of Rubens.*

Peter Paul Rubens (1577–1640): Educated in the classics, he served as a courtier and diplomat and gained international reputation as painter of the church and courts of Europe. He established at his home in Antwerp a large studio (''factory'') where many assistants carried out his designs for commissions in an unending stream of canvases.

Early style: *Venus and Adonis* reflects his years of study in Venice, where he was influenced by the fleshy forms, lush landscapes, and color of Titian. In *Raising of the Cross*, a 15-foot-high panel, he assimilated the styles of Michelangelo and Caravaggio to create tremendous straining figures that seethe with power and are strongly modeled in light and dark.

Mature style: In *Rape of the Daughters of Leucippus*, he created a spiral composition that slowly revolves in a great stream of energy. The solid forms are built up in color and defined by light. *Fall of the Damned* is composed of sweeping spirals as multitudes of figures hurdle downward in in an operatic crescendo. Marie de Medici commissioned 21 canvases (1620–25) depicting her life in allegories that reveal magnificent pomp, decorative splendor, rich coloring, and vigorous figures.

Late style: After his marriage to Helene Forment, Rubens retired to the country, where he painted sweeping landscapes with peasants, reminiscent of countryman Breughel. *Garden of Love* is a fantasy with aristocratic figures (Rubens and Helene) in a delightful garden setting.

Anthony Van Dyck (1599–1641): Rubens' assistant, he later became court painter to Charles I of England. His paintings are more subdued than Rubens'; the figures have more lightness and grace and the colors are less intense. *Charles I Hunting* shows an elegant, dignified, and stately ruler, standing with his hand on his hip in a regal pose. Behind is a Venetian-style landscape with the Thames River. Van Dyke conveys absolute authority blended with a romantic melancholy. This type of portrait exerted an impact on English painting down through the 19th century.

Key 50 Holland

OVERVIEW *After gaining its independence from Spain in 1580, the Protestant republic of Holland became a major maritime power and commercial country. Calvinism was opposed to religious images, pagan myths, classicism, historical subjects, and ornate churches, so patrons of the arts were the middle-class burghers who wanted paintings on their walls as evidence of wealth and social status.*

Little Dutch Masters: Artists specialized in one or more types of painting—genre, still life, seascapes, houses, and interiors. The title "Little Dutch Masters" refers only to the small size of the paintings, not the quality. The naturalistic style goes back to the Netherlandish tradition of the Van Eycks; the light and dark patterns came from Italy.

Jan Vermeer (1632–75): The most highly regarded master, he worked in Delft. His neat, comfortable interiors show middle-class inhabitants engaged in common household tasks and recreation. Figures are usually caught in the act—frozen animation— of opening a window, drinking wine, talking, and are illuminated by silvery light. Subtle glowing colors, serenity, and order distinguish his work.

Willem Kalf (1619–93): His still lifes—objects cast against dark background—sparkle in reflected light. Goblets, glass, carpets are rendered with remarkable texture and precision.

Jacob van Ruisdael (1628–82): His spacious landscapes suggest the infinite universe. The sky often fills two thirds of the composition. The heavy clouds sweep across the heavens, casting dark and light patterns on the earth below.

Meindert Hobbema (1638–1709): He created more picturesque landscapes, with thick dark trees, rich vegetation, muddy paths with small figures, and appealing red-roofed farmhouses.

Jan Steen (1626–79): He owned a cafe and often portrayed his patrons eating, drinking, and thoroughly enjoying themselves.

Pieter de Hooch (c.1629–77): His precisely defined interiors show family members caught in everyday activities, such as a daughter showing polished silver vessel to her mother, a child and mother in kitchen, etc. Homes have a geometric floor, comfortable furnishings, and are rendered in strong dark and light patterns. He carries the viewer's eye into a precisely detailed background.

Key 51 Rembrandt and Hals

OVERVIEW *During this gold age of Dutch painting, artists like Rembrandt and Hals created large-scale canvases that are indebted to Caravaggesque chiaroscuro.*

Rembrandt van Rijn (1606–69): One of the great geniuses in Western art, he came from Leyden and painted in Amsterdam. Unlike other Dutch artists, he depicts a wide range of subjects: Biblical, classical, landscape, portraits, group compositions. He refined light and shade into fine nuances that blended together to express emotion, character, and mood. Portraits probed the states of the human soul, and the humanity of his religious paintings appealed to the believer.

- His early work shows the influence of Caravaggio. Forms are descriptive and the blended brushstrokes create a smooth surface combined with a dramatic chiaroscuro as in the early self portraits and *Supper at Emmaus.*
- His mature style is increasingly subjective. Compositions are arranged within a box-like space and bathed in a golden light, using warm colors and spatial effects as *The Night Watch (The Company of Captain Frans Banning Cocq), The Holy Family, Risen Christ at Emmaus.*
- The late style is marked by more intensely psychological paintings built up in heavy **impasto**, with increased depth and breadth and less dense chiaroscuro, as in *Moses with the Tablets of the Law, Conspiracy of Julius Civilis, The Syndics Guild.*

Frans Hals (1580–1666): He is famed for his group portrait compositions. With acute psychological perception and a spontaneous brushstroke, he vividly communicated the character of his sitter.

- His mature style is seen in portraits of affluent Dutch burghers—jaunty, confident, and self-assured. He captured minute expressions in an intimate confrontation, as *Balthasar Coymans*, shown with his arm over a red chair. With a light, fleeting brush, Hals captured the instantaneous moment. A habitue of cafes, he portrayed patrons with a comic air, as *Malle Babbe* (Mad Bab), shown with a wide toothless grin, holding a tankard while an owl perches on her shoulder: Group portraits like *The Archers of St. Adrian* convey the high spirits of a luxurious banquet as officers turn away from table to see who is entering the room.
- In his late style, *Women Regents of Old Men's Home at Haarlem* is more subdued. Ghostly images of women emerge from a dark, mysterious background, showing the influence of Caravaggio and Rembrandt.

Key 52 England and America

OVERVIEW *The 17th century was an age of turmoil and civil war in England. By the end of the century Parliament gained power over the king. Starting in 1607, English settlements were established in America along the Atlantic seaboard from Canada to Florida. Settlers thought of themselves as English, and in Puritan New England built self-contained farming and trading villages.*

English architecture: Inigo Jones (1573–1652), architect to James I and Charles I, studied in Italy, and the influence of Palladio is evident in the *Banqueting Hall*. A clean, symmetrical block, it has two superimposed orders, pilasters at the ends, and balustrade roof. Christopher Wren (1632–1723) built *St. Paul's* with a mix of Palladian, French, and Italian Baroque features. Two foreground towers flank the great dome and tower lantern; below are superimposed paired columns like those on the Louvre. Wren also designed many charming churches, marked with tall pointed towers.

New England architecture: Working with builders' guides, Puritans built framed, half-timbered wooden houses based on the Tudor style. Huge central chimney, lean-to extension (salt box), steep pitched roof, overhanging second story, and low, compact rooms are found in the John Ward, Parson Capen, and other houses. The *Old Ship Meeting House* is designed so that the congregation faces the preacher. Settlers also made their own furniture.

American sculpture: Tombstones were carved with ornate motifs and a scalloped top. Later they were embellished with such motifs as winged skull, hourglass, crossed bones, skeleton—all dealing with the fear and terror of death.

New England painting: Limners—anonymous, untrained craftsmen—painted individual and group portraits of the Puritans. Working from engravings of Holbein's portraits in England, they defined the figures sharply in line with little modeling of facial features. Emphasis is placed on ornate dress and costume; figures are flattened, rigid, with somewhat distorted proportions, and cast against a dark, unadorned background. They are severe hard-shaped groups of unsmiling people. One of the few known limners was Thomas Smith, who portrayed himself with his hand resting on a human skull. By 1690 seven limners, each with another business in addition to portrait painting, were known to be active in Boston, a city of 8,000 inhabitants.

Theme 11 ROCOCO: 1700–1775

*T*he Age of the Enlightenment witnessed advances in science and technology and a belief in reason, empiricism, and the natural rights of man, which culminated in the American and French revolutions and marked the beginning of the modern world. Rococo, first developed in France, was encouraged by Louis XIV, who urged that paintings be more youthful and lighthearted. The fine and decorative arts reflected the elegance of the aristocracy: forms were ornate, sensual, and capricious with a spirit of gaiety and novelty, using delicate rhythmic lines and patterns. In keeping with the age, the Rococo style broke with academic rules and restrictions to create a distinctive expression.

INDIVIDUAL KEYS IN THIS THEME

53	Paris
54	London and Venice
55	Germany and America

Key 53 Paris

OVERVIEW *Hotels or elegant townhouses were the focus of Rococo art, a term derived from the small stones and shells used in interior decoration.*

History: This was the age of the Enlightenment, when philosophers and writers attacked tradition and the abuses of the monarchy, aristocracy, and clergy. Reason and common sense led to revolutions and the emergency of democracy. Louis XV reigned during the first half of the century in Paris, the social capital of Europe.

Architecture: Rococo style emphasized interior design as in the *Salon de la Princess*, Hotel de Soubise. The feminine decorative spirit reflects the influence of Madame de Pompadour and Madame de Barry, who were patrons of the arts. Walls melt into the ceiling, and painting and sculpture are combined in a sinuous design enhanced with gilded moldings and natural motifs. The luxurious, fanciful design corresponds with the lustrous costumes, ornate furniture, glass, silver, and ceramics.

Sculpture: Clodion's *Nymph and Satyr*, an open, charming, fragile group of figures, reveals the playful, erotic exhilaration typical of Rococo.

Painting: Towards the end of the century the Academy was divided into two factions: those who advocated drawing (Poussinistes) and those who argued for color (Rubenistes). The latter won out when Watteau was elected to the Academy.

- Antoine Watteau (1684–1721), a Flemish artist, brought the late Rubens decorative style to Paris. *Return from Cythera* shows a spacious, colorful, Venetian-style landscape with luxuriously dressed lovers and shimmers with aristocratic taste.
- François Boucher (1703–70) portrayed themes of love and erotic mythological frivolity, as in *Cupid as Captive*. In his pictures, sensuous female figures, often nude, cavort in luscious landscapes painted in soft pastel colors.
- In *The Swing*, Jean-Honoré Fragonard (1732–1806) created a luxuriant park full of colorful flowers bathed in a soft light with graceful, floating aristocratic figures. His portraits are idealized, lively, and confident in expression.
- Jean-Baptiste-Siméon Chardin (1699–1779) portrayed the life of the middle class household in a way reminiscent of the Dutch masters. His still lifes are composed of firmly placed and solidly rendered objects that represent the life of common man.

Decorative arts: This was the great age of decorative art. Commodes and desks designed by ebonists were embellished with exotic veneers and bronze ormolu mounts; graceful chairs were covered with colorful materials; ornate silver was made by highly praised designers; floral decorations covered faience and porcelain (a secret of manufacture learned from China).

Key 54 London and Venice

OVERVIEW *The center of the Industrial Revolution and machine age, English cities were transformed into urban factory centers where wealthy merchants exerted an impact on the government. Venice's gilded life was off set by the misery of the lower classes and people fled the city. The upper class pursued gambling, gossip, festivals, and love intrigues until 1797 when Napoleon's invasion ended the city's self-destructive carnival.*

English architecture: Rococo was not readily accepted in England, where Baroque taste prevailed. Vanbrugh's Blenheim Palace, Oxfordshire is a large-scale ponderous country estate designed as a theatrical, extravagant, and picturesque structure.

English painting: This is the great age of English portrait painting.
- Thomas Gainsborough (1727–88), the favorite portrait painter of English high society, worked in the Van Dyck manner. *Mrs. Siddons* is rendered in a light, feathery brushstroke that conveys a lyrical charm and cool elegance. *The Blue Boy*, clothed in an elaborate, fashionable costume with idealized features, is posed before a decorative landscape.
- Joshua Reynolds (1723–92), rival of Gainsborough, was appointed first director of the Royal Academy in 1768 and wrote "Discourses," devoted to rules and theories of art. His portraits were more strongly modeled, as *Lord Heathfield*, a heavy, burly English military officer.
- William Hogarth (1697–1764) represented the wealthy middle class and satirized contemporary life in London in paintings and prints. He depicted moral themes in a series of narrative scenes, such as *Marriage a la Mode*. Bright colors and spontaneous brushwork distinguish his style.

Venetian painting: Bright cheerful colors and studies of Venice itself characterize this period.
- Giambattista Tiepolo (1696–1770), noted for colorful, illusionistic murals, gained an international reputation. *Institute of the Rosary*, painted in bright colors on the ceiling of the Church of the Gesuati, is filled with elegant graceful figures flying across vast sunlit skies. *Cleopatra's Feast* in the Palazzio Labia is remarkably illusionistic. The wall is painted away with balcony, architectural

elements, and stairs with a figure ascending towards the festive group gathered around a table.

- Canaletto (1697–1768) accurately portrayed the Grand Canal as in *Santa Maria della Salute*, with effective perspective blended with soft grays, cool yellows, and colorful atmosphere.
- Francesco Guardi (1712–93) in *The Lagoon* depicted the swan song of Venice with delicate brushwork, shimmering surfaces, and vast, spacious sea and sky.

Key 55 Germany and America

OVERVIEW *The Rococo style adopted in Germany in the 18th century blended Italian Baroque, French Rococo and indigenous German traditions to produce spectacular ornate churches. Increasing wealth in America brought the desire for increasing comfort and luxury*

German architecture: Fantastic and playful decoration is found on the churches of this period.
- Dominikus Zimmermann in *Die Weis*, (1745–54), a pilgrimage church in Bavaria, combined on the interior oval and oblong shapes decorated with pink and ornate stucco motifs, frescoes, and white sculpture.
- Balthasar Neumann's (1687–1753) *Church of Vierzehnheiligen* (Bamberg) has an undulating Rococo facade with rounded corners and large windows that flood the interior with bright light. Within, a vivacious architectural fantasy of flowing molded elements creates a floating, hovering design of ovals and circles in a bewildering continuous motion that dematerializes the structure.

American architecture: Georgian houses are based on style of the Italian Renaissance (Palladio). Larger and more spacious, they have two chimneys, large windows, and a balustraded classical facade and are painted in contrasting colors. Interiors have high ceilings and elegant decorative furnishings, including marble fireplaces, chandeliers, Chippendale furniture, ornate silver and Chinese decorative motifs.

American painting: Feke, Smibert, and other artists worked in the English portrait style to do portraits of colonists wearing their finest clothing and seated on expensive chairs or framed against spacious, colorful landscapes. Unlike the English style, however, the forms are sharply defined in line, faces are realistic, and the figures are rigid, self-conscious, and often awkward.
- John Singleton Copley (c.1738–1815) was the foremost painter in the colonies. In Boston he portrayed leading politicians and merchants in a more relaxed and convincing style. He captured the personal characteristics of the sitter in *Paul Revere* with linear exactitude. *Mr. and Mrs. Thomas Mifflin* are casually posed and rendered in rich colors and precise drawing. Portraits reveal the intensity of his vision. After the Revolution, his paintings in London took on a more colorful, graceful and decorative style.

- Benjamin West (1738–1820), who came from Philadelphia, studied in Europe and settled in London. He was appointed second director of the Royal Academy after the death of Reynolds. *William Penn with Indians* is an academic composition with figures symmetrically placed within a box-like space. *Death of General Wolfe*, held in great esteem, shows soldiers in authentic costume enacting a contemporary event. The romantic characterization appealed to the sensibilities of the age.

Theme 12 NEOCLASSICISM, ROMANTICISM, REALISM: 1775–1874

*A*rchaeological discoveries at Pompeii, Herculaneum, and Paestum in southern Italy plus the writings of Stuart and Rivett and Winkelmann sparked intense interest in the classical past. Ancient Rome and Greece became symbols of revolt, heroism, self-sacrifice, and Spartan simplicity. Neoclassicism became the basis of academic art, but the political and social revolutions contributed to the reactionary movements of Romanticism and Realism that challenged the dogma of the academy. Artists proclaimed their individuality and portrayed exotic scenes with great emotion or realistically depicted the struggle, anguish, and suffering of the lower classes of society.

Key 56 Neoclassicism in France

OVERVIEW *Napoleon shared the enthusiasm for antiquity. He saw himself as a Roman emperor; Paris became the "new Rome."*

Architecture: Artists deliberately sought to imitate ancient models.
- Jacques Germain Soufflot's (1713–80) *Pantheon* represents Roman grandeur. The temple was designed with archaeological exactitude; the colonnaded dome was based on that of St. Peter's.
- Barthélemy Vignon's (c.1762–1828) *La Madeleine*, transformed into Napoleon's Temple of Glory, was placed on a podium with a single flight of stairs and a series of columns.
- Charles Percier and P.F.L. Fontaine built the *Arc de Triomphe* based on the Arch of Septimus Severus in Rome. It is surmounted by a victorious chariot pulled by horses. Their *Vendome Column* imitated Trajan's Column (Rome) and is embellished with relief carvings that illustrated the story of Napoleon's campaigns.

Sculpture: Antonio Canova (1757–1822) was brought from Rome to carve statues of Napoleon and his family. *Pauline Borghese* is shown reclining on an ancient couch like the classical goddess, Venus.

Painting: Historic subjects on heroic themes replace the frivolity of the Rococo period. Couture's *Romans of the Decadence* recreates the building and sculpture of the Roman Empire; symmetrically placed depraved figures confirm the virtues of the present.

Jacques Louis David (1748–1825): Court painter of Napoleon, he studied in Rome, where he adapted the classical style that reflected the moral purpose of the Revolution.
- *Oath of the Horatii* and *Death of Socrates* take place within a box-like space based on Italian Renaissance compositions; figures, symmetrically arranged in the center, are rendered in a precise linear style with a limited palette. The sculpturesque figures and ancient costumes and architecture convey the severity, stoicism, and heroic spirit of the Greco-Roman past.
- In *The Coronation of Napoleon*, the emperor stands in the center of the choir of Notre Dame Cathedral, Paris, surrounded by crowds of people—accurate portraits of those present—as he places the crown on Josephine's head.
- *Madame Recamier*, wearing a classical gown, reclines on an Empire chaise lounge with a Pompeian lamp nearby. The sculptural form, restriction of color, and classical setting typify the Neoclassic.

Key 57 Jean Auguste Dominique
Ingres

OVERVIEW *David's foremost student, Ingres (1780–1867) adhered to the principles of Neoclassicism throughout his life. He studied in Rome and was fascinated by the art of Raphael and Greco-Roman sculpture. In Florence, he was impressed with the Mannerists and paintings of Fra Angelico. He studiously avoided any emotion in his art and was critical of the Romanticists and Rubens.*

Valpincon Bather (1808): The nude, seated on a bed with her back to the viewer, is rendered with graceful linear contours and a cool, smoothly brushed surface. The subtle distortion of the nude probably was influenced by the Mannerists.

The Vow of Louis XIII (1824): It was executed in Italy and became an immediate success when shown in France, making Ingres a leader of the Neoclassicists. The Madonna and Child and symmetrical composition flanked by curtains reflect the High Renaissance formula and refined beauty of Raphael's Holy Family figures.

Apotheosis of Homer (1827): This is one of his major historical works. Typical are the rigid symmetry, balance, order, and classical forms, particularly the Ionic temple in the background. Blind Homer is seated on the top step crowned by the laurel and flanked below by two females representing the *Iliad* and the *Odyssey*. Gathered around are classical scholars as well as Raphael, da Vinci, Fra Angelico, Dante, Poussin, and French and English writers.

Francois Marius Granat (1807): This portrait is of an artist friend who had also won the Prix de Rome. In the background is the Medici Palace where he and Ingres studied. The pyramidal body and landscape background are High Renaissance in style. The linear, rhythmic contours, mass and solidity of the form, and smoothly rendered, warm, appealing features characterize the art of Ingres.

Contesse d'Haussonville (1845): In this superb Neoclassic portrait, the subject stands in a room resting her head on her hand and is reflected in a mirror (a device of 19th century painters as well as few earlier artists—Velásquez, Van Eyck). Her idealized features recall Raphael, but the meticulous, precisely defined linear details of the objects and smoothly blended brushstrokes are distinctive of Ingres.

Odalisque with the Slave (1842): This painting exemplifies Ingres' interest later in life in sensuous female nudes, often in exotic settings. The half nude woman reclining in an ecstatic twisted pose accompanied with a fully dressed musician is derivative of Venetian 16th century painting (Giorgione, Titian).

The Turkish Bath (1853–63): A cluster of nude women of the harem are in similar twisted, undulating poses. One in the foreground was taken from Bather of Alpincon, others from other works. But the classical facial masks, the forced, unnatural attitudes of the figures, and the exotic setting typify the late Ingres. The compressed, illogical space is Mannerist, as are the proportions of the figures.

Drawings: Ingres was an extraordinary draftsman, evident in exquisite pencil drawings such as *The Stamaty Family* (1818). With a sensitive, delicate line that suggests volumes, he selectively defined the figures, leaving much of the paper untouched.

Key 58 Neoclassicism in England and America

OVERVIEW *Archaeological excavations in Italy inspired a return to reason, nature, morality, and noble simplicity and calm grandeur of the Greeks.*

English architecture: Great country houses are the most significant buildings of this period.
- William Kent's (1684–1748) *Chiswick House* was influenced by Palladio's *Villa Rotunda*, evident in the central dome, columnar portico, and symmetrical rectangular plan. The picturesque informality of the surrounding English garden was the fashion of the age.
- Robert Adam (1728–92) pursued the classical revival in interior designs such as *Home House* with round arches, pilasters, and the cool geometric precision of plan.

American architecture: Public buildings were deliberately designed after classical models.
- Thomas Jefferson (1743–1826) was the foremost Neoclassical architect. He designed the *Virginia State Capital* (Richmond) after the Maison Caree in France, the first grand classical public building in the United States. His home at *Monticello* was based on the Villa Rotunda, while the *Library* on the campus of the University of Virginia was based on the Pantheon.
- Benjamin Henry Latrobe (1764–1820) was the most influential Federal architect. His *Catholic Church* in Baltimore recalls Soufflot's Pantheon with large dome, temple front, and classical ornament on the interior.
- Latrobe and Charles Bulfinch (1763–1844), assisted by Jefferson, designed the nation's capitol as an ancient Roman structure surmounted with an impressive dome inspired by St. Peter's Cathedral.
- James Hoban (c.1762–1831) designed the White House with a Roman exterior and a cool, refined Greek-type interior.

American sculpture: Greenough in Italy designed the huge marble statue of George Washington seated on ancient throne and clothed in Roman toga with hand upraised in the monumental majesty of Zeus.

American painting: Portraits and historic paintings were the most common.

- John Trumbull (1756–1843), who studied with West in London, painted four murals displayed in the rotunda of the national capital. *Signing of the Declaration of Independence* conforms to the Neoclassic box-like space, with balanced placement of realistically portrayed leaders signing the historic document.
- Samuel B. Morse (1791–1872) in *Old House of Representatives* depicted each politician within the classical architectural interior.
- Charles Wilson Peale (1741–1827), an extraordinarily gifted man, in *Self Portrait in Museum*, is shown raising the drapery to reveal his collection of natural history objects.
- Gilbert Stuart (1755–1828) painted about 1,000 portraits of the major personalities of the nation; best known are his portraits of George Washington.

Key 59 Romanticism in France

OVERVIEW *Romanticism was swept in on the wave of political unrest following the Revolution and fall of Napoleon's empire. Romanticism emphasized freedom, equality, and liberty of thought and revolted against tradition and authority.*

The Romantic artist: The artist became an authority unto himself—free to select any subject and express it in personal and emotional terms. Reacting against the growing industrialization, artists turned to Medieval themes and to the exotic lands of North America, the Near East and the ancient world. As a result, Romanticist artists were attacked by critics and alienated from society.

Architecture: *Gau's Church of St. Clotilde* was based on medieval designs of the 14th century and decorated with figures of such Merovingian saints as Saint Clotilde.

Painting: Scenes, dramatically portrayed, are characteristic of French Romantic painting. Rembrandt and Rubens were major influences.
- Baron Gros (1771–1835), pupil of David, portrayed *Pest House at Jaffa* in a romantic style. In the exotic moorish setting, Napoleon as a Christ figure stands among his dying and dead soldiers while dramatic dark and light patterns emphasize the gloom and misery of the scene.
- Jean Louis Gericault (1791–1824) painted *Mounted Officer of the Imperial Guard* with dramatic power. Horse and rider, placed on a sharp diagonal, are dynamically twisted in a war-torn setting and rendered with the suggestive brushstroke and strong color accents of the Romantics. *Raft of the Medusa* is composed on a diagonal filled with dead and dying sailors tossed by the stormy sea under a threatening sky. His series of portraits of inmates of an insane asylum shocked society.
- Ferdinand Delacroix (1798–1863), influenced by Gericault, painted *Dante and Vergil in Hell*, a composition reminiscent of Gericault's Raft. Grotesque, gruesome, and dead bodies swarm against the boat carrying the two poets. *Liberty Leading the People* (Revolution of 1830) shows dead and dying patriots sprawled before the powerful striding female of liberty. In North Africa (Morocco) Delacroix observed the intensity of color and painted lion hunts, Arabs, and haunting women in dramatic compositions rendered with spontaneous brushstrokes and vivid colors that con-

tributed to the movement. Delacroix explored complementary colors and recorded his ideas and concepts of art in a journal.

Sculpture: François Rude's (1784–1855) *Departure of the Volunteers*, a colossal relief on the Arc de Triomphe, glorifies the force, power, and surging figures of the volunteers rallying in defense of their republic. Bayre is noted for dynamic bronzes of animals fighting and devouring each other, as in *Jaguar Devouring a Hare*.

Key 60 Romanticism in England

OVERVIEW *In England, Romanticism was a reaction against the Industrial Revolution and included strong historical nationalism, admiration of nature, medievalism, and emphasis on individualism and self-expression.*

Architecture: Ornate buildings were decorated with exotic and medieval elements.
- Horace Walpole (1717–97) designed *Strawberry Hill* (Twickenham) as a Gothic castle with turrets, towers, battlements, and a panoply of chivalric elements from the medieval past.
- John Nash's (1752–1835) *Royal Pavillion* (Brighton) is exotic in style with Islamic domes, minarets, and ornate fanciful motifs.
- Sir Charles Barry and Augustus Charles Pugin's *Houses of Parliament* (after fire of 1834) imitating the late English Gothic style, was intended to express moral purity, spiritual intensity and medieval craftsmanship in contrast to inferior, machine-made, mass-produced commodities.

Painting: The emphasis was on emotion and the imagination of the artist.
- Henry Fuseli (1741–1825), a member of and teacher at the Royal Academy, painted *The Nightmare* as a Gothic fancy of macabre, sadistic creatures surrounding a helpless woman sprawled on a bed.
- William Blake (1757–1827), visionary, artist, poet, and book illustrator, was influenced by Michelangelo's muscular figures. He portrayed strange otherworldly images in watercolors like *Woman Snatched by Angels* and *Job's Despair*, in which the figures are defined with a sharp, wiry line and imbued with intense expression. Other designs are almost abstract.
- John Constable (1776–1837) conveyed the moods of landscapes. with dabs of pigment (broken color) that captured the effect of climate, weather, atmospheric changes, and the fleeting states of nature, as in *Haywain*. His coloristic technique influenced the French impressionists.
- J.M.W. Turner (1775–1851), a leading Romantic landscape painter, portrayed emotional experiences with nostalgic melancholy. Influenced by the 17th century landscapes of Lorraine, he moved from historical themes to painterly concerns that captured in red, orange, and yellow tonalities the forces of nature. In *Rain, Steam and Speed* he conveyed the power of a locomotive crossing

a bridge during a driving storm. With an almost abstract brush-stroke, he rendered the swirling wind and rain in hot, flamelike colors. His glowing canvases have an ethereal atmosphere and capture powerful emotion.

- The Pre-Raphaelites painted historical and fictional themes in a detailed linear style. Opposed to materialism and the ugliness of industrialized England, they focused on Shakespearean and Medieval themes. Their art had a self-conscious moral purpose and social awareness.

Key 61 Francisco Goya

OVERVIEW *Goya (1746–1828) was one of the greatest geniuses of the 19th century. His work ranges from decorative tapestry cartoons, through the realistic and satiric paintings of the period when he was court painter to the Spanish king and the portrayal of the horrors of the French invasion, and culminates in the nightmarish paintings near the end of his life.*

Early works: His tapestry cartoons are in the charming, colorful Rococo style. Aristocrats play games, flirt, oversee their estates. They are luxuriously clothed and placed within spacious decorative compositions.

Mature works: Although he was appointed court painter, Goya did not treat his royal and aristocratic subjects with idealizing respect.
- His portrait of the family of King Charles IV (1800) is reminiscent of Velásquez' *Las Meninas*, even including the artist himself in the background standing before a tall canvas. The incompetent king and dissolute Queen Louisa bear no trace of idealization; depravity and corruption are reflected in the ugly appearance of these life-size figures surrounded with generations of family members.
- *Maja Desnuda* (1800) is one of a pair of paintings of the same woman reclining on a couch, once clothed and once nude. This, the first true nude in Spanish art, reflects Venetian influence (Giorgione, Titian).
- In the Church La Florida, he executed frescoes influenced by Tiepolo and Mengs, who had visited the Spanish court. The religious figures are deftly rendered in loose brushstrokes and set against bright colorful backgrounds.
- *Josefa Bayeu* (1798), Goya's wife, was portrayed in a seated pose with a calm, almost resigned expression. The realistic modeling reflects the influence of Velásquez, who exerted the greatest impact on Goya.

Late work: These works include nightmare visions and despairing social protest.
- In *The Third of May* (1808) Goya painted a devastating scene six years after the actual event. The first ''social protest'' painting, it vividly reveals the inhumanity of warfare as helpless Spanish peasants are led towards the firing squad of French soldiers. In contrast

to the disciplined, faceless soldiers, the terrified victims throw up their arms in despair before dead bodies while others cover their eyes in terror. A lantern provides the only source of light in this dynamic, diagonally composed scene heightened by dramatic contrasts of dark and light, thick pigment, and bold, sweeping brushstrokes.

- *Saturn Devouring His Children* (1820–22), painted on the walls of Goya's house, depicts a horrible monster with a huge gaping mouth grasping his helpless nude son in massive hands. The glaring dark eyes, twisted body and limbs, dark background, and emotional power relate this work to Romanticism in one of its darker moods.

Graphics: Goya was also a superb graphic artist who, working in the etching aquatint technique, created several series of prints.

- *Los Caprichos* (The Caprices, 1796–98) portray an imaginative, satirical view of everyday events as performed by monsters, witches, beasts, and caricatures.
- *Los Desparates* (The Follies, 1813–19) are mysterious allegories, like *Ridiculous Folly*, where a teacher repeats by rote to deaf, dumb, and blind forms huddled on the decaying branch of a tree.
- *Tauromaquia* captures the excitement of the bullfight.
- *Disasters of War*, in 81 plates, powerfully shows the horror, terror, and atrocities of war that are as common today as they were in Spain when Goya lived.

Key 62 Romanticism in Germany and America

OVERVIEW *Romanticism was readily accepted in Germany, where the spirit had been prepared by Goethe, Schiller, and the great composers, and in America, where the westward movement opened strange new worlds.*

German painting: Caspar Friedrich, a northern German artist, showed the German medieval heritage in *Abbey Graveyard under Snow*. Gothic ruins, cold wintery trees, profound isolation, and a funeral procession of hooded bearers with a coffin exemplify the Romantic spirit. Meditative and pessimistic scenes of alienation, solitude, and death typify this artist.

American painting: The Catskill Mountains and Hudson River Valley played host to many landscape painters who shared a patriotic pride in their newly settled country.

- Thomas Cole (1801–48) painted *Expulsion from the Garden of Eden* as a dramatic, exotic world marked by a rocky gateway leading to the garden of paradise while the figures of Adam and Eve are driven out into the darkness of an ugly, decaying world. Swirling patterns of dark and brilliant light intensify the Romantic scene.
- George Inness (1825–94) in *Peace and Plenty* celebrated the end of the Civil War. With intense poetic feeling he portrayed the grandeur of American farmland. The vast landscape is typical of the Hudson River school.
- George Bingham (1811–79), who lived in Missouri, depicted frontier life in *Traders Descending the Missouri*, showing two trappers with a black fox tied to the end of their canoe. Romantic in spirit is the strange indefinable space.
- Frederick Church, Bierstadt, and other landscape artists depicted the Far West—the Rocky Mountains, Yellowstone, and Indian camps—with Romantic scale and drama.

American architecture: The medieval style influenced American architects and became characteristic of 19th century churches, universities, and public buildings.

- Furness designed the facade of the Pennsylvania Academy of Fine Arts in the dark stone of the Gothic style.
- Davis planned Gothic mansions and estates with a maze of rooms, hallways, staircases, towers, gables, and forests of turrets.

117

Key 63 Realism in France and America

OVERVIEW *Romanticism also affected the Realist painters, and both movements were a reaction against industrialism.*

French painting: Artists who portrayed the suffering of farmers and laborers were bitterly attacked by critics and public. Rejected by official exhibitions, the pressured Napoleon III to found the Salon des Refuss, open to all artists who emphasized the here and now.

- Honoré Daumier (1808–79) developed a quick, summary linear style with heavy impasto. In more than 4,000 lithographs he satirized politicians and lawyers and revealed his sympathy for the people. *Third Class Carriage* vividly shows the tragic poor riding in a bleak railroad car. *Uprising* recorded one of the many insurrections headed by a working class hero that rocked Paris.
- Gustave Courbet (1819–77) sought to record what he saw about him. In the large canvas *Burial at Ornans*, he shows a peasant funeral with realistic mourners gathered around an open grave in a cold, barren landscape. *Stone Breakers* shows the commonplace subject of a man and a boy laboring at the side of a road. Courbet built up landscapes with heavy pigment, using a palette knife.
- Jean Millet (1814–75) was one of several artists who lived and painted scenes near the village of Barbizon. His peasant scenes have a religious quality, as in *The Angelus*, in which a man and wife stop their work to pray. *The Sower* has a Michelangelesque grandeur as he strides across the field spreading seed.

American painting: Unlike their French counterparts, American artists who painted the life around them were well received.

- William Sidney Mount (1807–68) depicted everyday life on Long Island with linear accuracy, as in *Eel Fishing in Setauket*.
- Thomas Eakins (1844–1916), the leading painter in Philadelphia, portrayed *John Biglen in a Single Scull* with remarkable clarity and precision. *The Gross and Agnew Clinics* are faithful representations of eminent surgeons performing operations before medical students. Eakins' portraits are strongly realistic, yet melancholy.
- Winslow Homer (1836–1910), an illustrator for *Harper's Weekly*, recorded scenes of the Civil War, like *Prisoners at the Front*, with a propagandistic flavor. In a factual style, he did genre scenes of the country and children, like *Snap the Whip*. In Prout's Neck, Maine, where he settled (1881), Homer portrayed the surging power of the sea, storm-worn boulders, fog-bound shores, and the strength and courage of men who wrested a living from the sea.

Theme 13 IMPRESSIONISM AND POST IMPRESSIONISM

Between 1880 to 1900 Impressionism gained public acceptance. During this brief period, some of the now-famous artists worked in France and exhibited in Paris; others were bitterly attacked by critics and were unable to sell their work. They pursued their own personal directions in theme, technique, and style, but shared the bright impressionist palette, came under the influence of Japanese prints, and were affected by the camera and photography.

INDIVIDUAL KEYS IN THIS THEME	
64	Impressionism
65	Edouard Manet
66	Edgar Degas
67	Henri de Toulouse-Lautrec
68	Georges Seurat
69	Vincent Van Gogh
70	Paul Gauguin
71	Henri Rousseau
72	Paul Cézanne
73	Auguste Rodin
74	The Symbolists

Key 64 Impressionism

OVERVIEW *The use of bright, fragmented, pure color and a preoccupation with the effects of light were among the hallmarks of Impressionism.*

Architecture: Metal made possible many of the innovations in architecture.

- Henri Labrouste's *Bibliothque Sainte Genevive* (1850) has cast-iron Corinthian columns supporting barrel rooves resting on iron arches. In design, the structure adhered to traditional architectural forms in stone.
- John Paxton's *Crystal Palace* (1851) was a triumph of iron architecture. It was built in six months, using iron supports and glass panes that flooded the interior of the multiple galleries with light.
- Louis Sullivan in Chicago was the first modern architect to argue that ''form follows function'' (the slogan of 20th century architecture). He designed cast iron and steel skyscrapers with a masonry screen, like the *Carson, Pirie, Scott Building* in Chicago. This and other buildings he enhanced with Art Nouveau ornament.

Painting: High-keyed colors from synthetic materials, readily available in tubes, made it easy for artists to paint out of doors and study the fleeting effects of light. Photography encouraged the exploration of luminous colors. The introduction of Japanese print influenced asymmetrical compositions with rhythmic, flattened, brightly colored forms.

Claude Monet (1840–1926): His painting *Impression—Sunrise* labeled the movement, which was at first bitterly attacked by critics and public alike.

- Monet painted various conditions of light and atmosphere with a flickering network of color patches that seemed flooded with light, like *The Seine at Argenteuil* (1874). Colors are applied in pure hues, unmixed on the palette, and shredded or divided so that hues of great intensity are juxtaposed, creating a vividness of color and intensity of light that was to Monet an end in itself.
- In *Gare Saint Lazare*, a moving locomotive is rendered in a tissue of spots of contrasting colors, a palimpsest of pigment.
- In a series of studies of Rouen Cathedral, he dematerialized the stone facade into light effects at different times of day.
- *Cliffs at Les Petites Dalles* (1885), one of many seascapes, limits the visual experience to the effects of light and atmosphere. The

cliffs and jetty, sands and water, are of the same texture and substance.

- *Water Lilies*, a late work, is a shimmering reflection of color. The pond takes up the entire vast canvas as a weightless interplay of reflection and reality.

Camille Pissarro (1830–1903): *Boulevard des Italiens* (1897) is a study of sunlight, but the tone is subdued. Pissarro looks down on the street as in a Japanese print or snapshot. The scene is morning, and Pissarro captured the moment and atmosphere of carriages, crowds of people, trees, and buildings in the dabs and touches of color.

James McNeill Whistler (1834–1903): An American expatriate, he studied in Paris and settled in London. An advocate of "Art for Art's Sake," he was strongly impressed by Japanese prints and painting as well as by Impressionism. His paintings were analogous to music, like *Nocturne in Black and Gold: the Falling Rocket*, a suggestive arrangement of line, form, and color.

Key 65 Edouard Manet

OVERVIEW *Manet (1832–83) came from a wealthy family and studied with Coutoure but quarreled with the classical Academic doctrine advocated by the master. He visited Spain to see paintings of Velásquez and Goya and these affected his work. Manet sought freedom of expression and contributed to the modern concept of "Art for Art's sake." In Paris he became the center of a group of young, rebellious artists.*

Early work: Figures and faces are realistically drawn, with relatively flat blocks of color.

- *Lola de Valence* (1862) shows Manet's interest in Spanish themes. The dancer from a visiting Spanish troupe is posed standing against a neutral background with bright colors accenting her costume. This was one of a series of paintings on Spanish themes.
- *The Balcony* (1869) was obviously influenced by Goya's *Majas on a Balcony*. But in Manet's painting a well-dressed bourgeois family is seen as strong solid forms against a dark background.
- *Le Déjeuner sur l'Herbe* (1863) was a scandalous picture vehemently attacked by critics and public alike although based on the famous Venetian work by Giorgione—*Concert Champêtre*. Whereas the Renaissance master portrayed an idyllic classical theme with idealized figures, Manet depicted his friends and an artist's model as individual, realistic personalities. He reduced the forms to basic planes of flat color and eliminated shadows, as if the group were struck by an intense beam of light. Finally, he applied touches of bright color that were, according to the viewers, pictorial and not naturalistic.
- *Olympia* (1863) was also greeted with shock, even though the subject was based on Titian's *Venus of Urbino*. Instead of a beautiful classical goddess, Manet depicted a courtesan reclining on a bed, wearing high heeled shoes, with a flower in her hair and a black cat at the foot of the bed. Her servant brings a bouquet of flowers, probably from an admirer. Again, Manet flattened the forms in bright colored planes.
- *Emile Zola* (1868) shows the young writer seated before his desk with an open book and Japanese objects on the table and Japanese prints and a reproduction of *Olympia* on the far walls. Zola was an ardent defender of impressionist artists.

Later work: In these works Manet used a looser brushstroke.

- *Le Bon Bock* (1873) reveals the influence of Frans Hals in the free, loose brushstroke. Here a fat man seated at a table is smoking and drinking beer (Hals depicted similar themes). He is rendered in dark tones with white accents on the collar and hands and set against a dark background as in 17th century Dutch painting.

- *Boating* (1874) exemplifies Impressionist influence in the bright color, vivacious brushstroke, and airy, spacious composition. The theme was influenced by Monet's painting outdoors. Manet created a snapshot effect in the figures, who are cut off by the frame and seem unaware that they are seen. Japanese influence is shown in the high-pitched water that goes out of the picture frame, creating compressed space. The forms are bathed in light, and quick suggestive strokes with deft accents of color for eyes, nose, lips, and ear give the work a sparkle and informality that is distinctively Manet.

- *The Bar at the Folies-Bergére* (1881) is more compressed, with the bar in the immediate foreground filled with bottles and fruit. In the center is the figure of a barmaid caught off guard as if speaking to a customer, seen reflected in the mirror behind. Figures in the background are defined with quick suggestive brushstrokes.

Key 66 Edgar Degas

OVERVIEW *Degas (1834–1917) was of aristocratic birth and intellect. His father, a banker, wanted him to study law, but Degas gave it up for art.*

Style: Degas was grounded in academic methods, studied in Italy, was influenced by Ingres, and came under the spell of the Impressionists. A superb draftsman, he painted solid, penetrating portraits and imaginative Japanese-type compositions.

Early work: His themes were the life of Paris—cafés, theaters, racetracks, ballet, and his studio.
- *The Bellelli Family* (1859) was defined in a linear style with individual portraits. The father ignores the tall, imposing figure of his wife as he turns toward his daughters. The composition is structured with strong vertical and horizontal elements.
- *Pouting* (1872) is reminiscent of the realistic themes of Manet. A middle-class moment, when a woman pleads for a kiss from an angry man who rebuffs her, takes place within a solidly structured room.
- *Cotton Exchange at New Orleans* (1873) captures a group of men unawares within a room with a high pitched floor and strong vertical and horizontal accents in the windows, bookcases, and chairs.
- *Foyer of the Dance* (1872) is one of the many ballet scenes painted by Degas. He captures the momentary action of young dancers practicing under the eyes of the dance master. The floor is high pitched and girls arranged around the frame, leaving a vast open space of floor. The chair in the foreground and archway behind establish the focus and center of the composition.
- *Carriage at the Races* (1873) is another momentary snapshot composition, with carriages and horses cut off by the frame. Rich greens and blues create an airy, spacious effect.

Later work: Towards the end of his life, he abandoned oil for pastel, which enabled him to capitalize on his innate interest in line.
- *Ballerina and Lady with Fan* (1885) is seen from a high vantage point in the upper proscenium box, looking down on the ballet dancers. Degas enjoyed the unorthodox angle of vision, with figures cut off by the frame and arranged to fill the whole shallow space in an almost abstract composition. With deft brushstrokes he captured the animated, momentary movement.

- *After the Bath* (1890) reveals the linear contours of forms, brilliant color patterns, a flat composition, and the airy effect of the chalk colors. When his eyesight weakened, his style became broader and more abstract.

Sculpture: To compensate for his failing eyesight, Degas turned to wax statues that were later translated into bronze. As in his painting, he strove for momentary effects, the essence of reality enlivened by rough textural surfaces. In *Little Dancer* (1881) a slender, bony young dancer assumes a striking pose dressed in an actual woven skirt and hair ribbon.

Key 67 Henri de Toulouse-Lautrec

OVERVIEW *Determined to study art, Lautrec (1864–1901) came to Paris where he met with the Impressionists and came under the influence of Japanese prints and the art of Degas.*

Subject matter: He portrayed the sordid world of his Paris—cafés, restaurants, circus, theater, prostitutes, brothels, actors, and friends—in a detached realistic style.

- *A La Bastille* (1889) is a portrait of Jeanne Wenz seated at a table with a wine glass. The subdued color, black dress, and direct solid realistic style typify his early work.
- *La Dance au Moulin Rouge* (1890) is one of his largest canvases. Japanese influence is seen in the high-pitched floor and figures cut off by the frame, while the rich colors show Impressionist influence. Distinctive of Lautrec are lightly applied pigments, approaching watercolor, spontaneous linear accents, strong dark contours, and vertical brushstrokes that tend to flatten the forms.
- *Salon au Rue des Moulins* (1894) shows the reception room of a brothel, with the prostitutes sprawled on couches wearing revealing dresses and awaiting customers. He knew this depraved life of the city very well and defined it in a direct, convincing manner.
- *Monsieur, Madame, Le Chien* exemplifies his skill at caricature. With spontaneous brushstroke and telling lines, he lightly swept in the color, capturing the humorous and bored expression of the figures, cast against a flattened impressionistic background.
- *Au Cirque Fernando* has a Japanese-style high tilted floor; the open stage is bordered by the dramatically curved red lines of the stands holding the audience. The clown is cut off at the left as are the legs of the intense ringmaster. A massive horse with bowed head prances around the stage.
- *At the Moulin Rouge* (1892) is one of the best known works. A seated group of his friends are set back from the slashing angle of the orange balustrade in the immediate foreground. At the right is the disturbing green illuminated face of a woman with bright red lips and yellow hair. This snapshot composition shows the influence of Japanese prints and the work of Degas, but the violent play of color and rapid brushstroke is Lautrec.
- *La Tete de la Goulou*, probably a study for a canvas, was painted in oil on cardboard, a material he selected for many works. With

quick heavy strokes of pure color, he drastically simplified the portrait almost into abstraction.

Prints: Lautrec mastered lithography in 1892 and became an innovator in color lithography. He produced posters that for the first time became major works of art. He dabbed and speckled the surface with ink to create textures and expanded the potential for this graphic media. His prints are heavily indebted to Japanese graphics. *Divan Japonais* (1892) shows his typical flattened forms.

Key 68 Georges Seurat

OVERVIEW *Seurat (1859–91) was a systematic artist who adhered to rules more than any other painter.*

Style: Influenced by the color theories of Delacroix and the physicists Helmholtz and Chevreul, he worked with four colors—red, blue, yellow, and green—and related hues meticulously applied directly to the canvas as separate entities, a method called "divisionism." The term is often confused with "pointillism," wherein dots of pure color are placed on a white ground that is partially exposed. Like Cézanne, he strove to make Impressionism as durable as the art of museums and his work exerted an influence on the Fauves.

- *Bathers* (1883–84) is built up with horizontals that emphasize a calm and restful quality, typical of his work. The quiet permanence distinctive of his pictures has been compared to the calm of Piero della Francesca (15th century). Contours reduce the forms to almost geometric cylindrical shapes.

- *A Sunday Afternoon on the Island of La Grande Jatte* (1884–86) was built up from many sketches in black conte crayon and color studies in oil and crayon. The pictorial effect is based on the verticals of figures and trees, the horizontals in the shadows and white embankment, and the diagonals of the shoreline and shadows. The mother and daughter in white establish the center and fulcrum of the composition. The rigidity and formalism of the flattened forms was criticized as Egyptian. Seurat was concerned with pictorial shapes and not literal representation. All forms are interrelated in this tight-knit, ordered picture composed of countless dots of pure color that are even carried to the frame to provide harmonious transition. In contrast with the Impressionists' obsession for the fleeting sensation of light and color, Seurat sought to capture the essential quality of a scene and transfix it with simplified, almost geometric forms and precision of contour.

- *La Parade* (1887–89) portrays figures out of doors illuminated by gas jets above. Figures are arranged in a row as flattened silhouettes and set off by the dark pattern of the audience in the foreground. Behind, overlapping rectangles of flat walls and screens are reminiscent of the flatness of a Japanese print.

- *Circus* (1890–91), his last major painting, is composed as if looking down on the ring from above. A clown dominates the foreground while a rider on horseback quickly trots around the arena, bordered by a series of curved linear patterns. The intense yellows, oranges, and blues of the scene are harmoniously interrelated.

Key 69 Vincent Van Gogh

OVERVIEW *Born in Holland, Van Gogh (1853–1890), supported by his brother Theo, went to Paris where he met the Impressionists, particularly Pissarro and Lautrec. Anxious to work in nature, he moved to Arles, where he had an unfortunate encounter with Gauguin, suffered mental illness, and committed suicide after a brief ten-year career.*

Early work: *Potato Eaters* (1885) uses a dark palette of murky greens and browns. The awkwardly drawn rugged peasants are seated around a table illuminated by a small lamp hanging from the ceiling. This painting is typical of his early heavy-handed efforts.

Parisian period: *Portrait of Pere Tanguy* (1887) is a solid, directly rendered painting. Distinctive is the vivid play of intense colors and rapid brushstroke. Behind is a collection of Japanese prints that exerted a great impact on Van Gogh. *Night Cafe* (1888) captures the oppressive, sordid setting of a cafe rendered in incredible contrasts of color—green ceiling, red walls, yellow floor, green billiard table, and yellow radiating halo of light. Typical of Japanese prints are the high pitched floor and slumped drinkers crowding the frame. But the drama of the room with the strange apparition of the proprietor built up in a heavy impasto with spontaneously applied brushstrokes is distinctive of Van Gogh.

Provence: He came to this southern French city in 1888 and was overwhelmed by the brilliant sunlight of the countryside. He painted the sun-illuminated region with an explosive yellow applied thickly on the canvas in violent brushstrokes. Sometimes he even squeezed the color directly from the tubes onto the surface. *Entrance to the Public Garden at Arles* (1888) has the Japanese high-pitched composition, bold, directly defined figures, and vibrant colors.

Saint Remy: While an inmate at the asylum, he painted *Starry Night* (1889). Whirling and exploding stars and galaxies threaten the village below while a mysterious flame-like cypress tree surges up at the left. Color became a force that expressed emotions and feverish visions.

Auvers: *Crows over the Wheatfields* (1890) was one of his last paintings. A road boldly cuts through the fiery yellow wheat fields. Above is a vibrating greenish-blue sky with black silhouetted birds. Churning, swirling brushstrokes create a maelstrom on the surface.

Key 70 Paul Gauguin

OVERVIEW *Gauguin (1848–1903), a stockbroker in Paris, met and bought the work of Impressionists, particularly Pissarro. Soon he gave up business for art and worked in Brittany, Arles, Tahiti and the Marquesas Islands where he died. Gauguin rebelled against both the European artistic tradition and civilization.*

Early work: In Brittany at Pont-Aven and Paulder he painted solid Impressionist landscapes and Breton people. He became the center of a group of artists interested in intense color, flattened form, and dark outlines. Gauguin pursued a subjective expression and attacked the Impressionists because they "neglect the mysterious centers of thought."

- *Jacob Wrestling with the Angel* (1888) exemplifies his personal approach in the flaming red ground and the flat patterns of Breton women in black and white watching the wrestling figures. The dramatic diagonal of a tree trunk divides the composition of flattened forms and simplified patterns.
- *Self Portrait with Halo* (1889) shows Gauguin as a large man— actually he was short. The flattened composition, linear patterns, art nouveau motif terminating in a snake's head, and solid color patterns typify his style.

Later work: He created a remarkable series of decorative canvases based on the colors of the tropics.

- *Spirit of the Dead Watching* (1892) uses flattened, sombre colors with the suggestive volume of a nude girl on the bed. In this and other works, he inscribed the title above in the native language. The scene refers to his native wife, who was terrified by the darkness.
- *La Orana Maria* (1891), a native woman and her son, suggests the Virgin and Child; the two adoring women in the background were taken from the relief of a Japanese temple known to him in a photograph.
- *L'Appel* (1902) is distinctive for its rich harmonious colors, monumental drawing, and strong modeling. The high tilted perspective gives a tapestry effect to the design. Gauguin freed art from descriptive story telling to create an art of expressive color. He wrote, "Everything must be sacrificed to pure color...the intensity of the color indicates its nature."

- *Where Do We Come From? Who Are We? Where Are We Going?* one of his last works, was a huge mural that served as a monument after his death. In a vast landscape, standing and seated figures—some borrowed from his other paintings—are self-contained and unrelated to one another (as in Puvis de Chevannes' murals). The flat patterns, bold color, subjective expressions of figures, and purely personal style distinguish this work.

Woodcuts: Gauguin made a number of woodcuts and three-dimensional carvings that conform to the style and objective of his paintings.

Key 71 Henri Rousseau

OVERVIEW *A self-taught "Sunday painter," Rousseau (1844–1910) worked as a customs official and was known as Le Dounier. Because of his unconcern with realistic forms and perspective, his art has been called Primitive.*

Early work: Rousseau first signed his pictures in 1880 and exhibited with the Independents starting in 1886.
- *A Carnival Evening* (1886) has two figures in white costumes within a winter landscape that exemplifies the fantasy of a stage-set. Distinctive are the careful outlines, smooth surfaces, intricate detail, compressed space, and combination of reality and unreality. His dream world has a poetic and descriptive quality.

Later work: His naive, innocent, humorous style caught the attention of modern artists like Picasso.
- *The Wedding* (1904–5) is one of his most famous works. The figures, who are unidentified, have individualized faces and stand as motionless cut-outs on the same plane defined by flat outlines. The group is enhanced by colorful background trees and a humorous dog seated in the foreground.
- *Football Players* (1908) is perhaps his only work to depict animation. The composition is laid out as a Saint Andrews cross, and the four players with stereotyped features wear brightly colored striped costumes and socks. The field is framed by small trees. The rugby match is a charming, humorous fantasy.
- *Artillery Men* (1893–95) is a carefully constructed work probably inspired by a photograph. The curved arrangement of the soldiers is echoed by the cluster of trees behind them. Black tunics are marked with color accents and their feet have been painted, then covered with the green of grass—typical of his style.
- Jungle pictures like *The Dream* (1910) were based on his visits to the zoo, botanical gardens, postcards and photography, and his own vivid imagination. Within a luxuriant profusion of trees and flatly rendered leaves is a red couch with a reclining nude; behind is a snake charmer and lions peering out from the foliage. The exotic, otherworldly, dream-like quality anticipates Surrealism.
- *Sleeping Gypsy* (1897) is particularly Surrealistic. In a desert is a sleeping gypsy dressed in a striped robe with a mandolin and vase nearby; over him stands a lion. Beyond stretches a barren landscape with distant hills, and above is a full moon in a blue starry sky. The whole painting conveys a curious, trancelike mood.

Key 72 Paul Cézanne

OVERVIEW *A major revolutionary artist, Cézanne (1839–1906) set the stage for 20th century art and exerted a great impact on the cubists, Fauves, and abstract Expressionists.*

Style: He began as an Impressionist but wanted to make of Impressionism, "something solid and durable like the art in museums." He replaced the transient effects of light with a steady uniform light, reduced forms to geometrical equivalents (cylinders, spheres, and cones), and modeled in planes of color that served as a unifying and balancing factor. Creating structural and expressive compositions that re-created nature instead of reproducing it and defining the essence of the subject as felt by the artist became the basis of modern art.

Early work: *Uncle Dominic* (1865–67) was modeled in earth colors with broad vigorous strokes of a palette knife (like Courbet); strong outlines give the figure monumentality. *The Black Clock* (1869–71) is constructed of vertical and horizontal elements, with heavily modeled forms fitted together as an architectural wall.

Impressionist period: *House of the Hanged Man* (1873) was painted out of doors with heightened colors applied in short patchy strokes to capture the warm sunlight. The balanced formal structure is distinctive of Cézanne. *The Sea at L'Estaque* (1883–85) has the high-pitched horizon of Japanese prints as well as the vast open blue space of the sea. The planes and volumes of foreground forms and misty colors of the background make everything seem to come forward.

Later work: Cézanne worked increasingly with geometrical forms and blocks of color to give both a solidity and a two-dimensional feel to his canvases.
- *Rocks in the Forest of Fontainebleau* (1894–98) shows how he modulated the warm and cool colors to create advancing and receding planes. He applied patches of color throughout the surface that served to balance the picture firmly.
- Mont Sainte-Victoire, near Aix, became an obsession to Cézanne and he painted it about 60 times from every angle. Scenes of the mountain, painted from 1885 to 1906, dramatically reveal his objectives. The earlier work is marked by deep space with a viaduct and mountain range in the background set off by tall slender trees in the foreground while a curving river flanked by houses fills the middle ground. Forms are modeled in blocks and planes of

color. The last work, in 1906, reduces the scene to a patchwork of colors in a strikingly abstract style. Masses of green bear little resemblance to nature, lighter touches of blue and a white sky seeming to hover on the surface and reinforce the two-dimensional character of the canvas. The rich color and exuberant spirit had a decided impact on Expressionist artists.

- *The Great Bathers* (1898–1905) has distorted figures in a landscape. Reduced to geometric forms, they echo the sweeping arched movements of the tall trees within a flattened abstract composition that was the culmination of his work and led to Cubism.

Key 73 Auguste Rodin

OVERVIEW *Perhaps the greatest sculptor of the 19th century, Rodin (1840–1917) was inspired by Renaissance masters—Donatello and Michelangelo—as well as the Impressionists.*

Style: A modeler, he worked in wax and clay, emphasizing the unfinished quality of his forms whose rough wrinkled textural surfaces produced changing patterns of reflections comparable to the paintings of Monet. But unlike Monet, Rodin was concerned with feelings, emotions, and psychological states of mind.

Age of Bronze (1876): One of his first works, it was also one of the most controversial. The anatomy of the boy was so accurate and convincing that Rodin had to prove it was not a cast from a living model. The twisted anguished pose recalls Michelangelo's *Dying Slave*.

Gates of Hell (1880): Rodin never finished these doors, inspired by Dante's *Inferno* and Ghiberti's *Gates of Paradise* (Key 33). They were cast in bronze after his death. Preliminary studies consisted of a swarming mass of figures, varied in scale, arranged in dazzling shifts of direction within an indeterminate composition that shows intense pessimism and anxiety. Tortured, agonized forms are reminiscent of Michelangelo's *Last Judgment*.

- *The Thinker* was derived from Michelangelo's *Jeremiah* on the Sistine Ceiling as well as from Medieval images of Adam brooding. The uneven, gouged surface captures the play of light.
- *The Kiss* (1886) was cut from marble, leaving the rough hewn base in contrast with the smooth surfaces of the two figures in a sensuous embrace. The softly rendered, luminous marble surface produces a glowing, Impressionist light around the figures.

Burghers of Calais (1886): Commemorating a group of heroic citizens of the 14th century, the group was to be placed at street level so that the viewer participated in the event. Rodin created naturalistic men wearing coarse robes and modeled with animated gestures and tragic faces that reflected the fear of death. Rough hewn, deeply gouged depressions and protuberances catch and reflect the light.

Balzac (1893–97): The honored writer was portrayed as a monolith wrapped in a robe, and erupting out of the huge bulk of his body was a forceful head with a disturbed, almost disdainful expression. The drastic reduction of form and overpowering presence led to modern sculpture.

Key 74 Symbolists

OVERVIEW *Some artists before the turn of the 20th century created haunting, shocking, terrifying and nightmarish visions.*

Odilon Redon (1840–1916): A painter and graphic artist, he depicted *Orpheus* in 1903 with upturned face and lyre in a mountain landscape that appears like a richly colored dream. Other images were influenced by Goya, like *The Balloon Eye* (1882), a series of prints dedicated to Edgar Allan Poe. A single dominant eye, symbolic of God, is transformed into a floating balloon. Redon's aim was, "putting the logic of the visible at the service of the invisible."

James Ensor (1860–49): In his huge *The Entry of Christ into Brussels* (1889), Christ is seen in a street with a mass of masked colorful figures. *The Intrigue* (1890) shows grotesque, depraved faces of people at a carnival.

Edvard Munch (1863–1947): A Norwegian, he came to Paris in 1889 and was influenced by Van Gogh and Gauguin. *The Scream* (1893) has a figure walking along the seashore with hands pressed to the head in terror, heightened by the reverberating landscape and intense red, yellow, and green background. This powerful Expressionistic work contributed to German Expressionism.

Gustav Klimt (1862–1910): He established the Austrian Secessionists, influenced by the earlier Berlin Secessionists. *The Kiss* (1908) is built up of a striking gold gown decorated with geometric mosaic colors and covering an embracing couple. The whole conveys an otherworldly quality.

Gustave Moreau (1826–1898): His world of fantasy was inspired by Medieval and exotic themes. In *The Apparition* (1876), an exotically dressed Salome rears back from the sudden apparition of the bleeding head of St. John. The scene is dramatized by the oriental setting and dark background.

The Nabis: Followers of Gauguin called themselves "Nabis," a Hebrew word for "prophet." Their work reveals the influence of the Impressionists and Japanese prints.

Edouard Vuillard (1868–1940): His small, domestic scenes, like *Interior at L'Etang-la-Ville* (1893), were done in Divisionist technique with small touches of bright color in all-over patterns rapidly brushed across the canvas, leaving the white areas as part of the composition.

Theme 14 20TH CENTURY ART

*T*he tempo of change in the 20th century gained momentum as one "ism" followed another in rapid sequence. The incredible number of "isms" reflected the pluralistic international society. Three major concepts dominated the first half of the century: Expressionism, Abstractionism, and Fantasy. The avant-garde who spearheaded these movements drew their inspiration and forms from the art of prehistoric, primitive, and early cultures in different parts of the world.

Key 75 Expressionism

OVERVIEW *Artists experimented with media and invented new forms while retaining their uniqueness and individuality. They found in primitive art a spontaneity, energy, and design that affected their expressions.*

Fauves: Their exhibition in Paris (1905) showed paintings that freed color from descriptive representation and, with bold brush strokes and heavy pigment, made the picture surface a single spatial plane.
- Henri Matisse (1869–1954), leader of the Fauves, in *Joie de Vivre* depicted a group of nudes with flexible, unbroken contours and clashing, strident, arbitrary colors. In *Red Studio*, floating colorful objects are cast against flat planes of red walls and floor. In *Green Stripe*, the woman's face is divided by a prominent green stripe; "deliberate disharmonies" and jarring shapes are used for emotional effect.
- André Derain's (1880–1954) *Pool of London* looks down on a cargo ship and small boats in port rendered with violent, clashing colors applied with powerful brush strokes.

Die Brücke (The Bridge): Working in Dresden (1905), they were, like the Fauves, captivated by tribal sculpture from Oceania and the Congo. Their paintings were more anguished and pessimistic than those of the Fauves.
- Emil Nolde (1867–1956), in *Doubting Thomas*, depicted the religious scene as a barbaric ritual enacted by emaciated figures with mask-like faces and jagged patches of color.
- Ernst Ludwig Kirchner (1880–1938), in *Masks*, portrayed a hanging cluster of distorted masks with strident colors against a blue background. *Berlin Street Scene* showed prostitutes and dandies with sense of despair and anxiety.

Die Blaue Reiter (Munich): Vassily Kandinsky (1866–1944), the intellectual Russian lawyer who dominated this group, also served as director of the Bauhaus in Weimer (1922–23). He painted the first purely abstract work in the West on the eve of World War I, *Composition VII*. The shapes, forms, and colors in this explosive composition have no equivalent in the natural world. The constantly expanding and contracting space created a subconscious spontaneous expression related to music.

- Franz Marc, who formed this movement with Kandinsky, painted *Deer in the Wood*, where the colors and hues of the animals had symbolic meaning.
- Oskar Kokoschka (1886–1980), Austrian, celebrated romantic love in *Bride of the Wind*, a whirlwind scene of artist and mistress swept above a mountain in ecstatic emotion.
- Max Beckman (1884–1950) portrayed scenes of devastation and horror in Germany after World War I, as in *The Night*, an indictment of official cruelty and torture in twisted tortured forms and intense colors.

Key 76 Abstractionism in Paris

OVERVIEW *Cubism reflected new intellectual points of view free from representational convention. Figures and landscapes were reduced to a system of geometric shapes, patterns, lines, angles, and sometimes swirls of color. It paralleled the space-time concepts of physicists and led to non-objectivism.*

Beginnings: After his Impressionist Blue and Pink periods, Pablo Picasso (1881–1973), painted the revolutionary *Les Demoiselles d'Avignon* (1907), which marked the beginning of Cubism. The composition is conceived as an independent construction. Space is eliminated as the foreground merges with the background; figures are transformed into flat, angular forms; three heads are adapted from African masks while the others are reminiscent of ancient Iberian sculpture.

Analytical Cubism: Developed by Picasso and his colleague Georges Braque (1882–1963), it is characterized by fragmented contours, transparent planes hovering in a shallow space, muted colors, and pyramidal composition, as in Picasso's *Accordianist* (1911). The figure is presented from several angles in a temporal sequence.

Synthetic Cubism: Created by these artists in 1912, it shattered reality. Found materials like newspaper, wallpaper, music sheets, etc., were attached to the surface in bright-colored, overlapping shapes that create an almost relief sculpture, as in *The Bottle of Suze*. Structural lines and color accents emphasize the surface plane; a striking composition is made out of discarded materials.

Picasso: In the delightful *Three Musicians* (1921), broken shapes of the three figures are filled with flat, bright color that seem to move in the syncopated rhythm of music. On the other hand, *Guernica* (1937), painted in black, gray, and white, is a powerful indictment of modern totalitarianism. Figures portrayed in violent unexpected contortions communicate the horror of the senseless bombing of a helpless Spanish town.

Fernand Leger (1881–1955): He pursued the Cubist revolution in compositions that have the sharp precision of machines, as in *The City*. He combined fragments of urban life—telephone poles, billboards, robotlike people, and buildings—into a lively colorful design.

Marcel Duchamp (1887–1968): In *Nude Descending a Staircase* (1912) he analyzed the figures into cubist planes to create the effect of movement in a closely spaced series of fragmented elements.

Robert Delaunay: Arguing that "color is form and subject," he believed art should be confined to the rhythmic interplay of contrasting areas of color. *Discs: Sun and Moon* (1913) was based on a color wheel, and the geometric pattern of colors may have had a symbolic meaning.

Key 77 Abstractionism outside Paris

OVERVIEW *Cubism exerted an impact on artists outside of Paris—Futurists (Milan); De Stijl (Holland), and Suprematists and Constructivists (Russia).*

Futurists: Following the manifesto of Marinetti, they sought to reconcile man with machines and were fascinated with the speed of engines, automobiles, and airplanes. They attacked traditional Italian art and culture, reduced forms to planes, and composed almost abstract canvases of multiple images that tried to show movement as the motion picture did.
- Severini, in *Dynamic Hieroglyphic of Bal Tabarin,* created swirling rhythms of dancers in brilliantly colored cubist planes.

De Stijl: The Dutch painter Piet Mondrian (1872–1944), one of the most radical abstractionists, called his style NeoPlasticism. In *Composition with Red, Black, and Yellow* (1930) he built up a mathematically precise design of horizontal and vertical black lines on a white canvas with three primary hues that established a harmonious, subtle equilibrium.

Suprematism: This movement was represented by Kasimir Malevich (1878–1935), who strove for pure geometric abstraction. *Black Square on White Square* (1913) aimed at the expression of feeling independent of visual forms; abstraction can go no further than *White on White* (1918). Malevich believed art was a spiritual activity.

Sculpture: Among the sculptors at the turn of the century who were related to Cubism were Maillol (*Mediterranean*) and Lembruck (*Standing Youth*), who conceived their forms in geometric terms.
- Constantin Brancusi (1876–1957) created highly simplified shapes of universal beauty like *The Kiss* (1908), block-like slabs of stone with the fewest possible elements, and bronzes like *Bird in Space* (1927), which suggests a bird's sudden upward sweeping movement.
- Raymond Duchamp-Villon in *The Great Horse* conveys the horse's dynamic power in a twisted geometric design with piston-rod legs.
- Umberto Boccioni, a Futurist, portrayed in bronze a dashing human figure, *Universal Forms of Continuity in Space* (1913), with sweeping aerial turbulence symbolizing the dynamism of modern life.
- Henry Moore in *Two Forms* (1936) created slab-like metamorphic images as mysterious as Stonehenge. A series of recumbent human

figures were composed of massive interlocking shapes pierced in an open design.

- Tatlin (Russia) designed the model of tower, *Monument to the Third International*, as a swirling, leaning openwork of steel, wood, and glass in cubic and pyramidal shapes.
- Pevsner and Gabo (Russia) created forms out of plastic materials that blended science with art. *Torso* by Pevsnar in plastic and copper sheeting was composed of precise geometric units.

Key 78 Fantastic art

OVERVIEW *The international Dada and Surrealistic movements best exemplified fantastic art between World War I and II.*

Dada: A group of intellectuals who escaped to Zurich (in 1915), where they attacked the meaninglessness of war and all forms of cultural standard and artistic activity, and gave themselves this nonsensical name. The movement spread to New York, Paris, Berlin, Cologne and Hanover.
- Marcel Duchamp (1887–1968) was the leading spirit of Dada. His *Bride Stripped Bare by Her Bachelors* (1923) is an abstract image rendered in paint, lead foil, and quicksilver sandwiched between double layers of glass. The work eludes interpretation; possibly it may depict erotic frustration. Duchamp also painted a moustache and goatee on a print of the Mona Lisa and exhibited Ready Mades—a bicycle wheel, snow shovel, and urinal—as art.
- Jean Arp (1887–1966) created imaginative, whimsical cardboard cut outs like *Mountain Table Anchors Navel* (1925).
- Schwitters (Hanover) created Merz pictures made of objects from the gutter and trash basket like *Merz Picture 19* (1920).

Surrealism: Emerging out of Dada, it explored psychic experience and was influenced by Freud. Surrealists strove to uncover the subconscious processes of thought by accidental and automatic effects that offered a new realm of imaginative possibilities to shock the viewer.
- Jean Miró revelled in unbridled fantasy. *Harlequin's Carnival* (1925) is composed of flat, linear, colorful amoeba-like shapes floating in space.
- Salvador Dali, under influence of Freud, depicted sexual symbolism and irrational objects defined with remarkable precision, as in *The Persistence of Memory* (1931), in which the wet watches destroy the very idea of time. *Soft Construction with Boiled Beans* reveals monstrous forms of astonishing power that may have been a premonition of Civil War.
- René Magritte produced humorous, witty images on the absurdity of everyday life.
- Marc Chagall, noted for painting, prints, stained glass and stage designs,was among the artists who pursued the current of fantasy. In *Self Portrait with Seven Fingers* (1912) he combined Cubist geometry with bright colors and his Russian-Jewish folk tradition.

- Giorgio De Chirico painted a strange series of barren and menacing cityscapes. *The Nostalgia of the Infinite* (1914) has a mysterious tower with flags and two figures surrounded by dark, disturbing shadows.
- Paul Klee, who taught at the Bauhaus (1921–31), was interested in the art of children and tribal peoples and depicted lively, poetic fantasies like *Dance Monster Atop My Soft Song* (1922), in which a weird creature is defined in a thin spontaneous line.

Key 79 Henri Matisse

OVERVIEW *After Fauvism, Matisse's art took on a more lyrical and structured style in painting, cut-outs, and murals. One of the most sensitive and influential artists of the 20th century, he explored a multitude of directions and his art constantly grew and expanded.*

Mlle Yvonne Landsberg (1914): A series of curved lines swirling around her figure creates a rhythmic movement of form and space.

The Piano Lesson (1916): A young boy's face is seen behind a piano placed within a large rectangular structured room that recalls Cubism. Flat planes of rich color are enlivened by a small figure at the left corner balancing an elongated form at the upper right. The linear rhythmic areas stand in contrast with the reduction of form.

The Moorish series (begun in 1921): These paintings are Impressionistic in the dabs of bright color, but the scenes reflect Matisse's fascination with Islamic art (he visited Morocco in 1911). Representative is *Decorative Figure on an Ornamental Background* (1927). Seated in a room decorated with delightful Oriental patterns is a strongly modeled and fleshy nude.

The Knife Thrower (1947): This is one of a series of cut outs that firmly established the two dimensional surface. This stencil form from the *Jazz* series consists of flat, bright-colored shapes combined with charming floral motifs.

Rosary Chapel (Vence, France, 1948–51): He designed the stained glass windows, murals, tiles, altar, doors, vestments, candlesticks, crucifix, and even the exterior spire, for the Dominican nuns. Instead of using traditional religious imagery, he created a colorful, joyous design in glass that bathed the interior in an enchanting yellow, blue, and green light. The murals, on the other hand, are devoid of color; their black and white represents the Dominican Order.

Zulma (1950): One of many such works executed when the artist was confined to his bed, it was made of gouache on cut and pasted papers in blue, green, and pink. The precise contours and flat patterns have a spontaneous, vibrant energy.

Drawings and prints: Matisse produced a multitude of line drawings and prints in a remarkably sensitive, free line that defined the quintessence of the forms with fewest possible elements. His graphics reveal an exquisite, tasteful sensibility.

Key 80 Pablo Picasso

OVERVIEW *The most prolific and versatile artist in Western art, Picasso produced an amazing quality of art in every media, even stage sets. While he explored all directions in the visual arts, he periodically returned to classic forms.*

The Bather (1922): The heavy, sculptured form is reminiscent of Classicism but reduced to simplified shapes.

Woman in White (1923): It conforms to the same Classical idiom in the well-proportioned seated body clothed in a white, thinly brushed gown.

Painter and Model (1928): Despite the drastic distortions of the flattened abstract shapes within a geometrically constructed composition, the figures can be discerned.

Girl Before a Mirror (1932): Composed as a stained glass composition, the simultaneous views of the girl are derived from Cubism. The geometric patterns of bright colors are stunning, and the inventive imagery has stimulated many controversial interpretations of the underlying meaning.

Bullfight (1934): Fascinated by the bullring, Picasso combined it with the Minotaur in a violent and ferocious combat, expressed in abbreviated forms, dynamic distortions, and vibrant, rapidly brushed-in, high-keyed colors.

Weeping Woman (1935): A well-dressed woman wearing a decorative hat suddenly collapses into devastating grief. In the distortion of the Cubistically defined facial features, tears, and hand placed against her mouth, Picasso sympathetically and powerfully captured a universal emotional anguish.

Cat with Bird (1939): In a premonition of World War II, a large, dark demonic cat with huge claws and glowing eyes tears a helpless bird to pieces.

Sculpture: An outstanding, imaginative sculptor, Picasso created many works in all media, such as *She Goat* (bronze, 1950), a bold, vigorous creature with exaggerated full stomach, thin neck, sturdy feet, large hanging head, and a rough-textured surface that reflects the light. *Bathers* (bronze, 1957) is a series of abstract forms constructed of pieces of board, broken sticks, broom handles, and discarded picture frame to create a magical power.

Graphics: Representatives of his prints in all media is the *Minotauron-achia Series* (etchings) that combine the bullfight with the Minotaur. He portrayed violent battles of life and death in dramatic dark and light patterns with direct, intense, and telling lines.

Ceramics: At Vallouris, he produced striking painted ceramics—plates and figural forms.

Key 81 Architecture

OVERVIEW *Twentieth Century architecture was revolutionized by industrial materials and functional design. Styles had no precedent in the past. Machines and technology inspired new forms; engineering and technology played a vital role.*

Art Nouveau: This turn-of-the-century style of decoration was based on sinuous, curvilinear floral patterns combined with a respect of materials.

Antonio Gaudi: The foremost architect of Barcelona, he designed the cut stone *Casa Milá* (1907) apartment house as a malleable structure with freely modeled restless undulations of the facade and roof.

Frank Lloyd Wright: His *Prairie Houses* were designed in the Cubist style, as was *Robie House* (1909), an asymmetrical, long, low rectangular structure with roofs extended beyond walls, a concealed entrance, open interior space, and an organic relationship of the house to the setting. *Kaufmann House* grows out of the setting as cantilevers extend over the waterfall. The structure is designed with sharp, clear lines and planes.

International Style: This 1920s style is defined by regularity in the spacing of clear, cubic units, lack of decoration, and an austere geometry based on a steel and concrete skeletal structure.
- Walter Gropius's *Bauhaus* at Dessau consists of three major blocks of rooms and studios connected by a bridge; walls are a continuous surface of glass.
- Gerrit Rietveldt in Schroeder House (1924), created sweeping planes, overhanging roofs, and rectalinear shapes free of ornament.
- Meis Van Der Rohe designed the *Lake Shore Apartments* (Chicago) as a luminous cage of glass with exquisite subtlety of proportions.
- Charles Le Corbusier's *Savoy House*, a low square box resting on stilts of reinforced concrete (called *pilotis*) became a "machine for living." The *Unite de Habitation* (1947–52) was supported on pillars and the apartments designed with richly painted screen louvres and balconies. *Church of Notre Dame du Haut* soars as a curvilinear fortress on the crest of a mountain; small stained glass windows create a magic, spiritual light.

Later styles: Technology and new materials contributed to new designs.

- Frank Lloyd Wright's *Guggenheim Museum* rejected the International Style in its expansive cylindrical shape, 90-foot-high spiraling interior, and bold monumental design.
- Buckminster Fuller pioneered prefabricated planned units of polyhedra elements that could be built of almost any material at low cost. His geodesic domes roofed the vast space of *American Pavilion* at the Expo '67 in Montreal.
- Louis Kahn in *The Center of British Art* at Yale University created an imaginative poetic form and pervasive calm interior.
- I.M. Pei's *National Gallery* addition was designed as an aggregation of angular masses on an irregular site with a vast spacious courtyard.
- Piano and Roger's *Pompidou Center*, Paris, was a most exciting original design that emulated a Gothic cathedral in exoskeletons. Metal supports on the exterior and functional interior elements were brightly painted.

Theme 15 AMERICAN ART SINCE 1945

*I*n the wake of World War II, the revolutionary spirit in America exploded with the Abstract Expressionists followed by a bewildering series of styles. Modern European artists like Duchamp, Mondrian, and Hofmann came to America and provided the catalyst for artists and movements of the New York School that quickly gained worldwide prominence. Modern materials and methods opened new dimensions of creativity in the visual arts. Huge canvases enveloped the viewer, sculpture too large for a museum or gallery was placed out-of-doors as a complement for architecture and nature. With traditional barriers shattered, American artists turned to assemblage, junk sculpture, happenings, computer art, and even shaped the landscape into designs and patterns.

INDIVIDUAL KEYS IN THIS THEME

82 Abstract expressionism

83 Pop art

84 Op, color field, and minimal art

85 Photo realism and conceptual art

Key 82 Abstract expressionism

OVERVIEW *After the Second World War, New York replaced Paris as the center of the art world. A rapid sequence of new movements exerted an impact on artists in Europe and Asia as art became international. The distinction between painting and sculpture diminished and visual forms were related to architectural space.*

Abstract expressionism (1945–60): This revolutionary movement reverberated throughout the world. It had its roots in the art of Kandinsky, the biomorphic shapes of Gorky, the automatic surrealistic style, Hofmann's drip technique, Navaho sand painting, Far Eastern painting, and a host of other influences.

- Jackson Pollock (1912–56) dominated the movement. He spread his huge canvases on the floor and treated the surface almost as a battleground—covering it with an explosive labyrinth of lines and a maze of shapes that threaten to shatter the surface. Holding cans of house paint, he flung, dripped, and poured the pigment while standing on a ladder or chair or moving around the canvas. Instead of brushes, he used sticks, trowels, knives, sand, broken glass, and whatever caught his fancy. This dynamic process of painting is called "Action Painting." The imagery was not purely accidental; Pollock had control over the composition. *Blue Poles* (1953) is a huge 16-foot canvas, built up of writhing layers of pigment, bright colors, and aluminum, structured by diagonally placed black poles.

- William de Kooning (1904), like Pollock, began as a realist artist but turned to abstract versions of the female figure. *Woman I* (1952) explodes across the surface of the canvas in restless rhythms, the anatomy fragmented, features without identity, dislocated in space, and infused with volcanic energy. With fury and abandon, he hurled a brush loaded with pigment at canvases stretched on the floor or nailed to the wall.

- Franz Kline (1910–62) shared the explosive power of the group and built up bold black patterns applied with a house painter's brush on huge white canvases tacked to the wall.

Sculpture: David Smith's welded steel *Hudson River Landscape* (1951) created a whiplash pattern of lines and shapes in sculpture. Theodore Roszak, in welded, brazed, and molten works like *Sea Sentinel* (1956), created torn, jagged, rough-textured forms that paralleled the Expressionism of the painters.

Key 83 Pop art

OVERVIEW *Pop artists of the 1960s realistically portrayed popular and banal objects that often satirized American society and the mass media and erased the line between commercial and fine art. Influences came from a London group (Hamilton, Kitaj), Duchamp, Dada, and illusionistic American painters like Harnett. With clarity, sharpness, and lack of emotion, the Pop artists conveyed a cool quality in both paintings and sculpture.*

Jasper Johns (1930–): Working in encaustic on canvas, he developed well-known themes in series, such as the American flag in *Three Flags* (1958). The flags are superimposed one above the other and color areas are subtly modulated to create the unreal quality.

Robert Rauschenberg (1925–): Seeking to bridge the gap between life and art, he pasted all kinds of materials onto his canvases—newspapers, rusty nails, bedsheets, pieces of rope, zippers, postcards, torn trousers, fabrics, and other random objects of everyday life—brushing the assemblage with thick dripping house paint to create textural surfaces, as in *Early in the Morning* (1963).

Roy Lichtenstein (1923–): He based his art on comic strips, making greatly enlarged copies of single frames, including the printed words, creating the paintings with a multitude of dots like those used for printing, as in *Girl at Piano* (1963), a canvas that measures 68″ x 48″.

Andy Warhol (1928–87): He recorded the repetition and monotony of modern life with huge machine-made repetitions of soup cans, Coca Cola bottles, Brillo boxes, comic strips, cars, and even the smiling face of Marilyn Monroe (1962) in silkscreen and oil on huge canvas (about 7 x 4 feet) to make a vivid statement about the manufactured myths of Hollywood and advertising.

Claes Oldenberg (1929–): His sculpture consisted of monumental images of banal objects like *Lipstick* that were set up in cities. He also mass produced plaster hamburgers with the green relish and ketchup oozing out. Unusual were the stuffed canvas forms of typewriters and a *Giant Ice Bag* (1970), made of plastic with metal and a motor inside—15′6″ x 18′ in diameter. The motor blew it up, made it twist, deflate, and fall, in an endless repetitive action.

George Segal (1924–): He gained fame with life-size white plaster images of ordinary people arranged in everyday settings: waiting at a gas station, seated on a porch, hanging letters on a movie marquee. The forms, made with molds from living models, had a ghastly white quality, like *Lovers on a Bed II* (1970). Exhibited on ground level, they made the spectator part of the figural group to heighten its reality.

Key 84 Op, color field, and minimal art

OVERVIEW *These movements have in common a reliance on color and the absence of representational forms.*

Op art: It was based on optical sensations and linear patterns that shimmer, shake, advance, recede, waver, twist, turn, and undulate, disturbing our vision and creating a hypnotic, dizzying experience or an exhilarating, stimulating experience. It is antirepresentational and devoid of emotion.

- Richard Anuskiewicz (1930–) in *Entrance to Green* (1970) depicted a series of vertical rectangles that seem to move towards the center of the canvas counterbalanced by warm and cool colors that create a resonant, vibrant surface.

Color field: In this movement, the surface of the canvas is drastically reduced to one or two fields of color stained on the surface with thin transparent color washes. Influence came from Mondrian and Rozanova.

- Barnett Newman (1905–70) on huge canvases applied two fields of color separated by a narrow fuzzy-edged stripe that created a suggestion of space. In *The Way II* (1969) he balanced the evocative red area with black stripes along the sides establishing the supremacy of the picture surface.
- Morris Louis (1912–62) built up the canvas with brightly colored chevron stripes, as in *Bridge* (1964). The chevrons shoot down from the top of the canvas in precisely defined shapes of color that seem to float against the vast white field.
- Frank Stella (1936–), strongly influenced by Mondrian, abandoned the vertical and horizontal structure for shifting directions of line and shaped canvases. In *Empress of India* (1965), an enormous canvas, 6′5″ x 18′8″, the linear chevron colored areas are related to the angular shaped canvas. Powdered metal added to pigment creates an iridescent quality that reinforces the hardness, coldness, and hypnotic quality of the work. Stella also worked with Day-Glo, polymer, aluminum, fiberglass, sheet metal, and relief constructions.

Minimal art: Minimal art was an impersonal expression with a single object that apparently had no meaning or significance. Sometimes called Primary Structure, it bears a kinship to architecture.

- Donald Judd (1928–) produced a series of identical geometric cubes of galvanized iron, one superimposed above the other. There is no trace of the sculptor's hand in these mathematically proportioned cubes enhanced with primary color on one or more sides.
- Ronald Bladen (1918–88) in *The X*, a huge painted steel construction, 22′8″ x 12′6″, created a commanding presence that dominates the space where it stands and tends to become part of the architecture.

Key 85 Photo realism and conceptual art

OVERVIEW *These movements returned to real objects but rejected any emotional involvement.*

Photo realism: Photo Realism is an offshoot of Pop Art, based on photographs of often banal subjects.
- Richard Estes (1936–) projected the photographed subject onto a canvas and then colored it with acrylic and oil paint. He often selected city scenes that he rendered with a precision of detail and sparkling with reflected images in large plate glass windows.
- Duane Hanson (1920–) created astonishing life-like figures in sculpture, like *Tourists* (1970). This life-size man and woman are realistically painted and carry accouterments of typical caricatures of American tourists abroad—cameras, bags, etc.

Conceptual art: The emphasis is on the planning and thinking of a work, while the execution follows as a secondary aspect. Performance Art is meant to stun the viewer as he participates in the creation. Earth Art shapes the landscape with machines or coverings.
- Sol Le Witt stated, "The idea or concept is the most important aspect of the work." The work of art is an idea that may or may not generate visible form, like Cy Twombly's *Untitled*.
- The Performance or "Happening" in Conceptual Art was usually planned and directed by an artist. In *18 Happenings in 6 Parts* (1959), Allen Kaprow presented a sequence of rehearsed events combined with photographs of shocking and erotic pictures. The audience enters into and becomes part of the staging as in a dramatic performance.
- The Earth Art movement of Conceptual Art was spearheaded by Robert Smithson (1938–78) in *Spiral Jetty*. Earth moving machines shaped the landscape of Great Salt Lake, Utah into a series of spiral mounds 1,500 feet long. Photographs made of the site also became a work of art. Christo (1935–) specialized in wrapping natural formations like the Grand Canyon with 1 million feet of orange fabric or setting up a *Running Fence* of 2,000 panels of white cloth supported on poles and cable that extended across 25 miles of the California landscape. In *Biscayne Bay, Miami* (1983) he surrounded islands with 6.5 million square feet of fuchsia-colored fabric creating the effect of waterlilies. All these works exist afterward only in photographs and documents.

GLOSSARY

agora
In ancient Greece, an open square or area used for public gatherings.

altarpiece
A panel or sculpture above and behind an altar.

ambulatory
The passageway around the apse and choir of a church.

amphora
A two-handled egg-shaped jar in ancient Greece.

apse
A semicircular niche at the east end of a Roman basilica or Christian church.

arcade
Series of arches supported by piers or columns.

architrave
Lintel or horizontal beam at base of entablature.

archivolt
One of a series of concentric moldings on a Romanesque or Gothic church.

atrium
Open entrance hall of a house or court in front of a church.

avant-garde
Referring to artists who work in a new style that breaks with tradition.

basilica
In ancient Rome, a rectangular building having an entrance on the long side; a Christian church with a longitudinal nave terminating in an apse and flanked by side aisles.

blind arcade
An arcade applied as decoration to a wall surface.

broken color	Short, thick strokes of paint laid over a ground color to create rich textures and intense light.
buttress	Exterior masonry support of an arch or vault.
campanile	A bell tower, usually standing alone next to a church.
capital	Crowning member of a column, pier or pilaster.
cartoon	Full-scale preparatory drawing for a painting, statue, or tapestry.
caryatid	A female figure used as a column; Atlantas is a male figure used as a column.
cella	Enclosed interior chamber of a temple, where cult statue is housed.
chiaroscuro	Play of light and dark to create the effect of modeling.
cire-perdue	The "lost wax" process of bronze casting.
clerestory	Part of building wall, pierced with windows to admit light, that rises above adjacent roof tops.
coffer	Recessed panel in a vault or ceiling, often decorative.
collage	Composition made by pasting various pieces of material onto a flat surface.
contrapposto	Counter-positioning of the body about a central axis to create tension.
cornice	Crowning projecting element of the entablature.

cromlech Circle of monolithic stones in the ancient world.

crossing Where the transept crosses the nave in a church.

cyclopean Massive, rough stone construction without mortar.

diptych A two-paneled altarpiece.

dolmen In the ancient world, large stones capped with a covering slab.

eclecticism Selecting from various sources to form a new style.

encaustic Painting with molten wax on wood panels or walls.

entablature Upper part of a building between the capital and roof.

etching Design incised on metal plate coated with wax. When the plate is immersed in acid, the exposed parts of the plate are eaten away by the acid, enabling the artist to achieve subtleties of line and tone.

faience Glazed earthenware or pottery.

fluting Shallow vertical grooves in the shaft of a column or pilaster.

fête galante Elegant and charming celebration of aristocratic life in Rococo paintings, especially those by Boucher and Fragonard.

flying buttress In Gothic architecture, the arch that springs from the upper part of the pier buttress and spans the side aisle roof to reinforce the nave wall.

foreshortening — Illusionistic contraction of a form or object on surface of a painting.

fresco — Painting executed on plaster with water base pigments.

frieze — Sculptured or ornamented band on a building or other flat surface.

genre — Painting that realistically depicts scenes from everyday life.

gesso — Mixture of plaster and glue spread on the surface in preparation of a painting.

grisaille — Monochrome painting in neutral grays to simulate sculpture.

groined vault — A vault formed by the intersection at right angles of two barrel vaults.

hieroglyphic — Symbols and pictures used in writing in ancient Egypt.

hue — Pure color as opposed to *tints*, which are produced by adding white to lighten the color, or *shades,* which are produced by adding black or another color to darken or subdue the color.

hypostyle hall — A hall whose roof is supported by columns.

icon — An image of a sacred subject often venerated in the Eastern Church.

iconography — Study of the symbolic and religious meaning of people, objects, and events in a work of art.

illuminated manuscript — Codices and scrolls decorated with images in rich colors, sometimes enhanced with gold and silver.

impasto	Pigment thickly applied to a panel or canvas.
Latin cross	A cross whose vertical member is longer than the horizontal one.
lithography	A process of print making on a flat stone or metal plate. After the design is drawn with a greasy crayon, water and printing ink are successively applied. The greasy areas repel water and absorb the ink.
local color	The actual color of an object in painting.
loggia	Open gallery or arcade.
mandorla	A large oval shape surrounding the image of Christ or the Virgin, indicating divinity or holiness.
megaron	In ancient Greece, rectangular hall fronted by an open two-column porch.
menhir	A single roughly cut stone standing alone or with others.
minaret	Tall slender tower attached to a mosque from which the muezzin calls the people to prayer.
monochrome	A painting in one color.
mosaic	Surface decoration made by embedding small pieces of colored glass or stone in cement, usually covering floors and walls.
mullion	Vertical element that divides a window or screen into partitions.
narthex	Porch or vestibule of a church preceeding the nave.

nave	The main part of a church, between the entrance and the choir.
obelisk	Tall tapering four-sided shaft of stone with a pyramidal apex in ancient Egypt.
oculus	Circular opening in a wall or apex of a dome.
ogee	Molding in a double or S-shaped curve.
order	A style of Classical architecture based on the design of the column and its entablature.
papyrus	An Egyptian plant from which paperlike writing material was made.
pediment	The triangular space formed by the sloping roof and cornice at the ends of a Classical temple.
peripteral	A building surrounded by a colonnade.
pilaster	Decorative flat vertical element with capital and base attached to a wall.
polyptych	An altarpiece consisting of three or more sections.
print	Design or picture represented in more than one copy—etching, engraving, lithograph, woodcut, etc.
pylon	Monumental entrance of Egyptian temple.
quatrefoil	Architectural ornament having four lobes or foils.
quattrocento	Italian name for 15th century (1400s).

reinforced concrete	Poured concrete with iron bars embedded within.
relief	Figures projecting from the background of sculptured surface in high, low or sunken relief.
retable	Architectural screen or wall with painting or decoration above and behind an altar.
rib	A slender masonry arch that forms the framework of Gothic vaulting.
rusticate	Bevelled edges of heavy stone blocks as in Renaissance architecture.
sarcophagus	Stone coffin.
stele	Carved stone slab or pillar that served as a grave or site marker.
stucco	Fine cement or plaster coating for walls.
stylobate	Upper step of the base of a Greek temple.
tell	A hill or mound marking an Egyptian or ancient Near Eastern habitation site.
tempera	Pigment mixed with egg yolk, glue or casein.
terra-cotta	Hard baked clay.
tholos	A circular structure or ancient circular tomb.
tondo	Circular painting or relief sculpture.
tracery	Ornamental stonework in Gothic architecture that supports a glass window.

Tenebrists

17th century European artists who worked with violent contrasts of dark and light.

transept

Where the axis crosses at right angles in a Latin-cross church.

triforium

Gallery between the nave arcades and the clerestory in a Gothic cathedral.

triptych

A three-paneled altarpiece.

trompe l'oeil

Illusionistic painting that attempts to create a three-dimensional object ("eye fooling").

trumeau

A pillar in the center of a Romanesque or Gothic portal.

tympanum

Space enclosed by lintel and arch over the doorway of a church.

volute

Spiral, scroll-like design of Greek Ionic capital.

ziggurat

Pyramidal structure of ancient Babylon consisting of a series of superimposed levels.

INDEX